"simplify" po

> 5 branches

7 (concept) = driftwood

23 landscape = Tree + distance

36 house

38 compos of woods water

41 { church interior (But NOT cho om
 { also Tree in landsc w/ depth

43 Tree (NB aerial perspe, on 49

< 49 = use of fixative

61 trees could "pan" and
 also 72 = Tree

72 _____ of _____

81 church ruin

84 " " sunset

82 stone wall

yosemite! → 91

93 men on horse

99 stone house
 (_____

110! composl

115

Seeing & Drawing

Mason Hayek

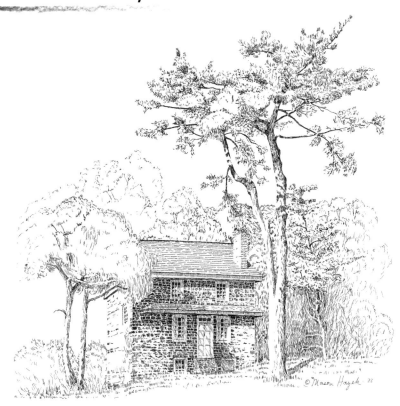

Sterling Publishing Co., Inc.
New York

Acknowledgments
I wish to express my appreciation to my wife, Doris,
and our daughter, Winifred, for their encouragement
and help and to Isabel Stein for her skillful editorial
work and guidance in preparing this book.

Library of Congress Cataloging-in-Publication Data
Hayek, Mason.
 Seeing & drawing / Mason Hayek.
 p. cm.
 Includes index.
 ISBN 0-8069-9354-5
 1. Drawing—Technique. I. Title: Seeing and drawing. II. Title.
NC730 .H385 2004
741.2—dc22

 2003024267

10 9 8 7 6 5 4 3 2 1

Published by Sterling Publishing Co., Inc.
387 Park Avenue South, New York, NY 10016
©2004 by Mason Hayek
Distributed in Canada by Sterling Publishing
c/o Canadian Manda Group, One Atlantic Avenue, Suite 105
Toronto, Ontario, Canada M6K 3E7
Distributed in Great Britain by Chrysalis Books Group PLC
The Chrysalis Building, Bramley Road, London W10 6SP, England
Distributed in Australia by Capricorn Link (Australia) Pty. Ltd.
P.O. Box 704, Windsor, NSW 2756, Australia

Sterling ISBN 0-8069-9354-5

Contents

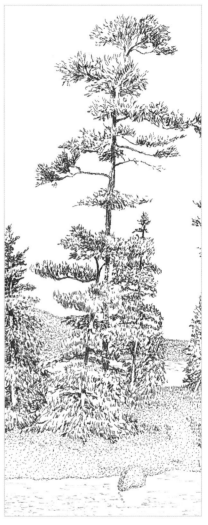

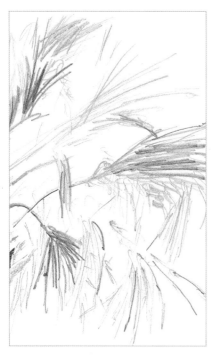

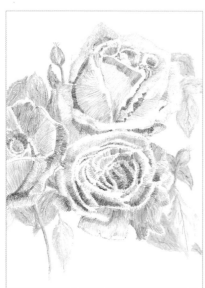

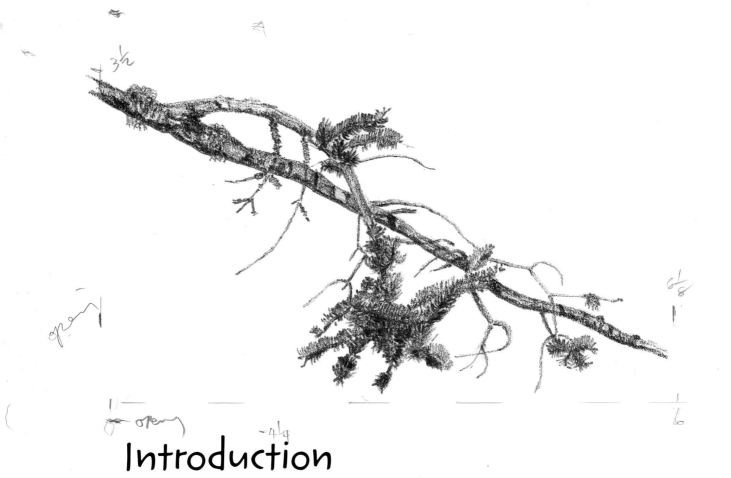

Introduction

If you want to draw, you can create results that will amaze you. You may respond, "Sure, but I can't even doodle. Stick figures are too advanced for me." If you can't draw, it's simply because you have not learned how. Drawing takes no special coordination, no "inherited" skill. If you can print or write, you can draw.

Did you like art as a child? What made you stop drawing pictures? Children do not worry if the people in their pictures reach to the second story of a house or if the chimney on the house looks ready to slide down the roof.

Children draw because drawing is fun and because they have scenes in mind that they want to capture on paper.

Adults, on the other hand, are often afraid to pick up a drawing pencil because they think the final result will be less than museum quality.

And what have you been missing? Why bother mastering drawing after all these years of getting along without it? If you lost your confidence as an artist during your preteen years, it's not too late to make

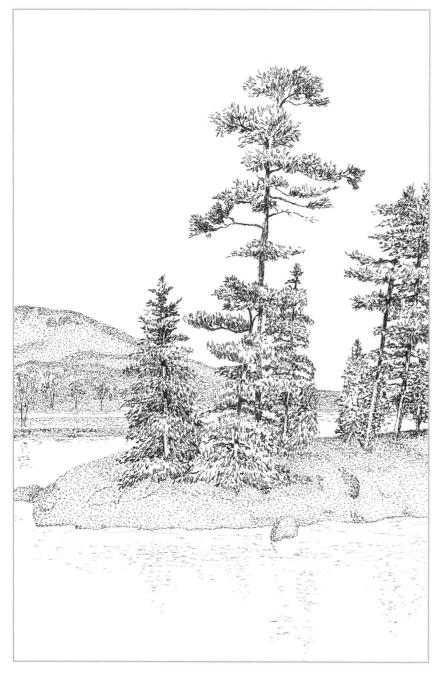

Blue Harbor, Maine; pen and ink (detail).

record of an important scene in your life, a way to relive being with the subject and to experience drawing it. It will be something to treasure in the future and a means of communicating a feeling to someone else.

Drawings are tangible evidence of your perspective on the world. For example, you may draw flowers, trees, or landscapes if you have a strong bond to nature. You may draw people or animals because you have a bond to them and an appreciation for their uniqueness, beauty, strength, or weakness, for their lives of struggle or for the tranquility that shows in their faces and bodies. You may draw buildings if you appreciate their design, their solidity, the connection you have with their inhabitants, and perhaps their age and resistance to aging or their frailty because of old age.

Through drawing, you will be able to express what you observe, forge connections with the subjects you draw, show your unique perspective on the world around you, see clearly the subjects you draw, and develop a way to record some important moments and scenes of your life.

Learn step by step. The goal of this book is to provide instructions, exercises, and a variety of examples to change your opinion from "I can't draw" to "I can draw." Drawing can

up for what you have been missing.

There are, in fact, many reasons why people like to draw. Probably, most people who draw do so because they enjoy expressing in a drawing what they see and feel. It's a way to record an experience, the experience of really seeing and feeling connected to an object or a scene. When you draw, you will find that time slips past because nothing matters except illustrating an object or a scene on paper. Whether the product is a quick sketch or a detailed drawing, it can be a

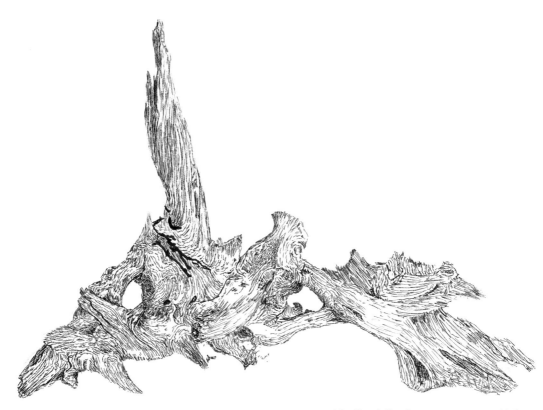

Mt. Katahdin pine stump; pen and ink.

produce a quick sketch or a detailed, perhaps slowly done, picture. Rapid sketching provides an intense, brief experience, a way to capture a fleeting scene or occurrence. Slow, detailed drawing provides a way to see and to be strongly connected to a subject. Both rapid sketching and slow drawing are ways to become intensely involved with the present, to shut out concerns, time, thoughts of the past and future, and even awareness of what is going on nearby. Drawing is a form of meditation.

Assemble the small number of materials listed for the first exercise and prepare to begin.

Right from the first exercise, you will be drawing. The chapters may be read from first to last or selectively. But if you are trying to draw for the first time (perhaps since childhood?), the first chapters and exercises may be critical. Try as many exercises as interest you. The more drawing you try, the more you will find drawing becoming an important part of your life. Unlike some kinds of artwork, drawing requires few materials, so getting set up is not difficult or discouraging. You may add a few materials as you go along and your projects become advanced.

For some drawings, working

from photographs may be convenient. You will probably benefit more, however, by working with real subjects, such as leaves, flowers, trees, people, animals, landscapes, or buildings.

The subject for Exercises 1, 2, and 3 is a leaf. By trying these exercises, you may see a leaf more clearly than ever before and learn that you can draw.

Note: The term "sketch" or "drawing" appears at times in the book with reference to a specific technique. "Sketch" refers to rapid sketching. "Drawing" indicates a slow, detailed drawing. For general use, however, "drawing" refers to either a sketch or a drawing.

CHAPTER 1

Getting Started

Drawing involves seeing clearly, so deeply for me when I draw that I feel I am part of the subject. For me, and probably for anyone, one of the greatest benefits of cultivating an interest in and skill in drawing is the experience of seeing deeply, more intensely than merely looking at a subject. I believe that people who draw (or paint) are artists not for what they do but for what they see.

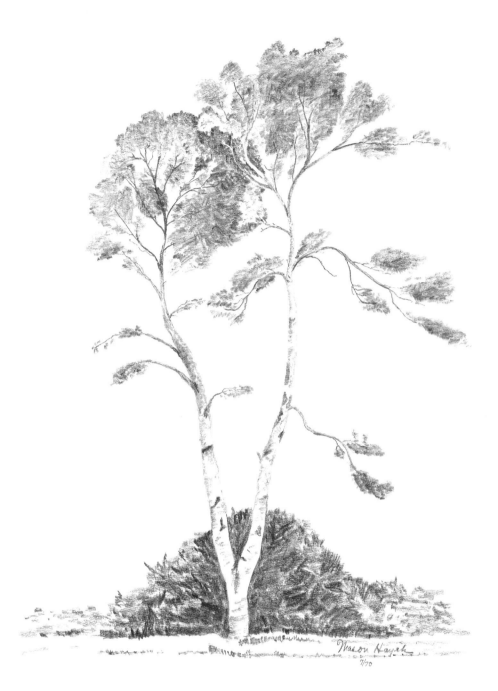

1-1 Birch; broad-stroke pencil.

Drawings, which are really just lines, dots, and shadings, are attempts to produce images of subjects and to capture the artist's feelings for the subjects.

Whenever I look at what I've drawn, I recover some of the experience of drawing, and sometimes someone else looking at a drawing senses part of what I've felt. Such drawing and capturing of feeling for a subject are not special skills I have or only "artists" have. The rewards of drawing are available to most people who have the motivation to try to draw and the patience to practice.

A drawing of a tree, for example, captures and transmits something of the essence of the tree. Just looking at a tree usually gives only an impression of the trunk and an array of branches, but really *seeing* the tree gives a feeling for the mass of the trunk, the weight and grace of the branches. And that tree in its surroundings will never be just a tree when the artist sees it again.

My drawings are not as accurate as photographs, but for me, the act of drawing and the resulting picture do something that taking a picture with a

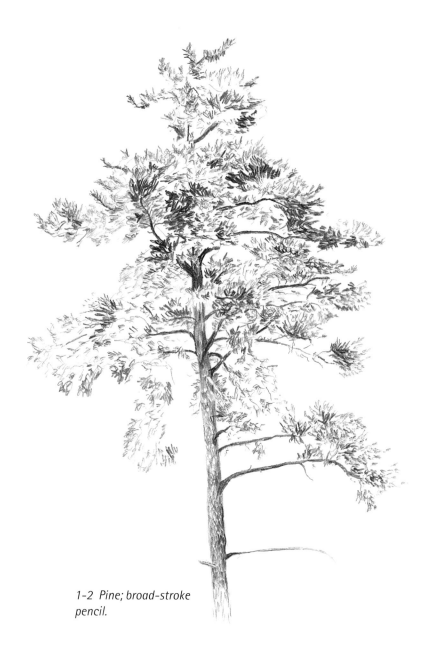

1-2 Pine; broad-stroke
pencil.

camera and looking at the
resulting photograph cannot
do. Yet I want my drawings to
be correct in their major
details.

Drawing realistically requires
you to follow this rule for
believing what you see: *Draw
what you see, not what you
think you see*. Most of us have
preconceived ideas of how
things around us look, and
many of those ideas are

wrong. Achieving three-
dimensional effects and show-
ing things in perspective
require you to follow the
abovementioned rule.

The drawing of a Kentucky
farm scene (1-3) illustrates the
principle of drawing what you
see. The nearby fence posts
appear taller than the distant
trees, and the nearest post
appears wider than a tree or
the house, although in reality

all the fence posts are much
smaller than a tree and are all
the same size.

When I started drawing consis-
tently, I found inspiration in
the realistic drawings in two
books, drawings that had
appealing compositions and
showed textures of subjects
such as trees and old
buildings. The books were:
Albert and Gertrude Kruse's
New Castle Sketches

(Wilmington, Greenwood Bookshop, 1932) and Ernest W. Watson's *Ernest Watson's Course in Pencil Sketching* (New York: Reinhold, 1956).

Ernest Watson's book showed how to use the "broad-stroke" pencil method for producing realistic drawings of a variety of subjects.

But I found that getting the hoped-for results requires more than finding inspiration, collecting pencils and paper, and then dashing off a picture. When I first set out on my own to draw, I was disappointed with the results. I wanted realistic pictures but thought I should complete every drawing quickly, even ones that included many details.

I asked our architect friend Albert Kruse how long it took him to make a detailed pencil drawing such as one of his drawings of buildings in Old New Castle, Delaware. His answer was, "Oh, not long—maybe 25 or 30 hours." That answer changed my approach to drawing and inspired me to draw even simple subjects as slowly as necessary in order to produce the results I wanted.

Then I found Kimon Nicolaides' book, *The Natural Way to Draw* (Boston: Houghton Mifflin, 1941), which showed how to make what he called contour, modified contour, and gesture drawings. I have described these processes in Exercises 1, 2, and 3.

I found that contour drawing and modified contour drawing produced surprising results for simple subjects and pointed the way to making complicated drawings. The exercises for these two drawing methods and the exercise for gesture drawing give techniques that are useful in producing simple sketches as well as detailed drawings.

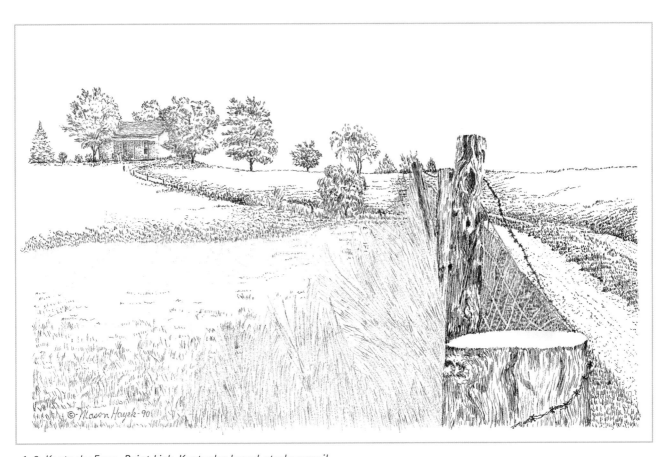

1-3 Kentucky Farm, Paint Lick, Kentucky; broad-stroke pencil.

Contour Drawing

Goal: To draw a simple subject by observing all its details

Subject: A leaf from a tree or plant

Materials: #2 or HB pencil with a sharp point, or a mechanical pencil with HB or softer lead; a few sheets of paper such as typewriter or copier paper (not the erasable kind) or a sketchbook about 8½ × 11 in. (21.5 × 28 cm).

Directions:

1. Place a leaf that provides a moderate challenge to draw in good light, positioned so that you can see its details as you draw.

2. Study the leaf carefully, and place your pencil point on the paper where you want to start drawing. Look at the leaf and imagine that your pencil is at a particular position on the edge of the leaf. Until you complete this exercise, *do not look back at the paper and pencil.*

3. Draw at the same time that you imagine moving the pencil and touching each part of the leaf.

4. Eventually return to the starting point, having gone completely around the leaf. Then, still without looking at the paper, imagine your pencil moving along the central vein of the leaf, then branching off on secondary veins or continuing on the central vein to the tip of the leaf. Draw at the same time that you are imagining this trip, including at least some of the secondary veins to complete the drawing. The project should occupy approximately a half hour.

If you were making a contour drawing of the oak leaf shown in 1-4, and you imagined your pencil first touching the end of the stem and then moving slowly to the first lobe of the leaf, your drawing might start and slowly advance as shown here.

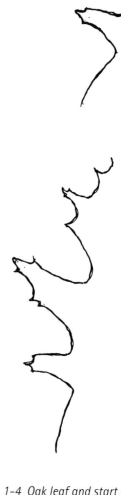

1-4 Oak leaf and start of contour drawing.

Modified Contour Drawing

Goal: To make a realistic drawing of a simple subject

Subject: The leaf used for the previous contour-drawing exercise

Materials: #2 or HB pencil with a sharp point, or a mechanical pencil with HB or softer lead; a few sheets of paper such as typewriter or copier paper (not the erasable kind) or a sketchbook about 8½ × 11 in. (21.5 × 28 cm).

Directions:

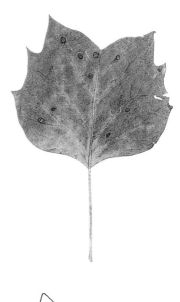

1. On a fresh sheet of paper, repeat the contour-drawing exercise, but this time, *look at the paper occasionally* to see where your pencil is and where it's going. Again, imagine the pencil moving slowly over the details of the leaf, millimeter by millimeter, as your pencil moves on the paper.

2. To make a modified contour drawing of the tulip-poplar leaf shown in 1-5 (or of any other leaf), you might start at the end of the stem and proceed upwards to produce a good picture of the leaf.

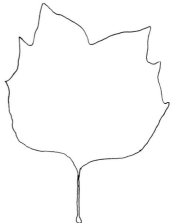

3. Study the shape and features of your leaf. Watch the leaf as you draw slowly. Glance periodically at your drawing to confirm the accuracy of your drawing.

4. Extend your drawing stepwise between glances at your drawing.

5. Finally, after a half hour or so, add details, such as the central vein and secondary veins of the leaf.

6. Complete the drawing, checking for accuracy a few times.

1-5 Photo and modified contour drawing of a tulip-poplar leaf.

Gesture Drawing

Goal: To see an object as a whole in making a quick sketch

Subject: The leaf used in contour drawing or another leaf

Materials: #2 or HB pencil with a sharp point, or a mechanical pencil with HB or softer lead; a few sheets of paper such as typewriter or copier paper (not the erasable kind) or a sketchbook about 8½ × 11 in. (21.5 × 28 cm).

Directions:

1. Read all the instructions before starting to draw. Drawing the subject should take no more than 20 seconds.

2. Hold your pencil loosely, and *draw rapidly and continuously, relying on your feeling for the subject.* Concentrate on features and the shape and mass of the subject simultaneously. Let lines cross other lines as your pencil expresses your reaction to the subject. Kimon Nicolaides writes, "You should draw not what the thing looks like, not even what it is, but what it is doing. Feel how . . . [the object] lifts or droops . . . pushes forward here . . . pulls back there . . . pushes out here . . . drops down easily there."

3. In the drawing process, your pencil roams almost at will. Keep the lines and your eyes moving rapidly. The drawing depends on sensation instead of logic. Stop at the end of about 20 seconds (1-6).

1-6 Gesture drawings of this oak leaf differ from one another, but each gives some feeling for the shape and mass of the original leaf.

My gesture drawings of the oak leaf in 1-6 differ from one another, but each gives some feeling for the shape and mass of the leaf.

Modified contour drawings also may be done in pen and ink or charcoal. Modified contour drawing is often an adequate technique for laying out a sketch or drawing. Detailed, step-by-step layout of parts of a subject, as illustrated in Chapter 9, is necessary only where special accuracy is desired. The time and effort spent in the layout can distinguish between a sketch and a drawing.

A sketch is different from a drawing in that a sketch may require only a few minutes to capture the appearance and essence of a subject, but for me, a drawing requires more care than a sketch and may involve work over several hours. Also, making a sketch involves the use of only the simplest materials, such as a pencil, a ballpoint or felt-tipped pen, and a sketchbook. Whether making a quick sketch or a detailed drawing, one encounters problems that are unique to that sketch or drawing. Such problems need not be discouraging if they are seen as interesting challenges whose solutions will provide lasting rewards as well as guidance for the next sketch or drawing.

Exercise 4 provides practice in the use of modified contour drawing. The proposed subject is the hand that is not holding your pencil, but the subject could be anything more complicated than the leaves of the first three exercises.

Modified Contour Drawing of a Complex Subject

Goal: To draw your hand or another subject of similar detail

Subject: The hand that isn't holding your pencil

Materials: #2 or HB pencil with a sharp point, or a mechanical pencil with HB or softer lead; a few sheets of paper such as typewriter or copier paper (not the erasable kind) or a sketchbook about 8½ × 11 in. (21.5 × 28 cm), plus a kneaded rubber or other soft eraser for making minor changes.

Directions:

1. Hold your hand in a position in which you can see parts of your fingers or all of them.

2. To simplify your drawing and to boost your confidence, you may want to draw just the outlines of your thumb and a finger or two before turning to your entire hand (see 1-7).

3. Note the relationships among the major features you will draw. If your hand is held as in 1-8, consider the relationships among the parts as well as the shape of your entire hand:

 ◆ Distance of thumb above fingers

 ◆ Portions of fingers covered

 ◆ Relative sizes and positions of thumb and fingers

 ◆ Relative lengths of fingers

 ◆ Positions of base of thumb near fingers

 ◆ Relative lengths of joints of fingers

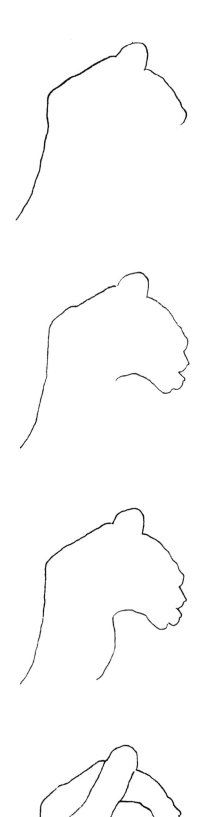

1-7 Beginning steps for a complex subject; the outline.

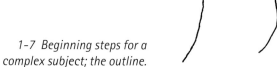

4. Imagine your pencil moving slowly, millimeter by millimeter, along the contours of your hand as the pencil moves slowly on the paper. Look at your drawing occasionally to ensure that you are drawing what you see. Draw what you see, even if some fingers appear to be short or seem to have different shapes than what you imagine fingers to be like. Some fingers may be hidden.

5. Do not name in your mind your fingers, fingernails, or wrist as you draw.

6. As you continue, complete the outline and add some of the internal lines that help define the shapes of the parts of your hand and fingers.

7. If you are satisfied with your drawing, complete it by adding a few details, such as wrinkles or lines. The object is to approximate the appearance of your thumb, fingers, or hand, not to produce a drawing as detailed as the one shown here; with practice, you may be able to draw as much detail as you wish.

1-8 The finished hand drawing.

Extending the Range of Subjects

1-9 Honeysuckle vine.

Goal: To experience the satisfaction of drawing objects from nature

Subject: A cluster of leaves or a small branch of a bush or tree

Materials: #2 or HB pencil with a sharp point, or a mechanical pencil with HB or softer lead; a few sheets of paper such as typewriter or copier paper (not the erasable kind) or a sketchbook about 8½ × 11 in. (21.5 × 28 cm), plus a kneaded rubber or other soft eraser for making minor changes.

Directions:

1. Select a cluster of leaves, as shown in 1-9. Do not try to make a drawing as detailed and shaded as 1-11 unless you wish to do so.

2. To get a feeling for the shapes of the leaves and stem, make a gesture drawing or two on a separate sheet of paper. Figure 1-10 is an example of a gesture drawing of the branch I drew in 1-11.

3. Consider whether the drawing will be wider than tall or the reverse, and then make a modified contour drawing of the branch of leaves. To help plan the layout, make a few marks on the drawing paper to show where the drawing will be placed, before you start.

4. To help your drawing, look for relationships among parts of the subject. For example, if you were drawing the branch in 1-11, you might consider these relationships:

 ◆ What are the relative positions of the leaves along the stem?

 ◆ How do the leaves compare with each other in size?

 ◆ Are the secondary veins of the leaves opposite each other or staggered?

 ◆ How far do the veins extend at the edges of the leaves?

 Start the drawing from any position on the branch or cluster of leaves, using the modified contour method. This process is an extension of the method of Exercises 2 and 4, where the purpose was to draw a complete outline of the subject before adding details.

5. Complete the drawing without shading, or else suggest shading by the use of closely spaced lines. (Chapters 2, 5, and 6 contain suggestions for shading.)

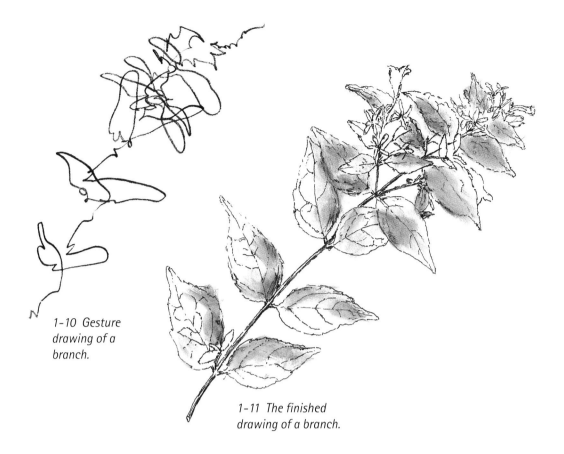

1-10 Gesture drawing of a branch.

1-11 The finished drawing of a branch.

Drawing What You See

Goal: To practice drawing what you see, not what you think you see

Subject: The hand that is not holding your pencil

Materials: #2 or HB pencil with a sharp point, or a mechanical pencil with HB or softer lead; a few sheets of paper such as typewriter or copier paper (not the erasable kind) or a sketchbook about 8½ × 11 in. (21.5 × 28 cm), plus a kneaded rubber or other soft eraser for making minor changes.

Directions:

1. Make several sketches of your hand or fingers in different positions. Try some in which the fingers are hidden and some that show your fingers with the fingertips facing you, in which the length of the fingers looks shorter than when your hand is stretched flat (the fingers are foreshortened).

2. Try some in which other parts of your hand are hidden.

Tools and Supplies

Drawing requires only a few tools, the minimum being
some paper and a pencil or two or a ballpoint or felt-
tipped pen. As your interest in drawing grows, you may
wish to add more tools. My most-used tools for on-
location drawing (perhaps outdoors) are drawing
devices, a sketchbook, a pocketknife, a small piece of
sandpaper or a sandpaper block for sharpening the
pencils, a kneaded-rubber eraser or other soft eraser

for occasional use, and a small case to hold the small objects (2-1). Sometimes it's helpful to have a small folding stool on which to sit when you do more than a quick sketch.

Indoors, detailed drawing may require drawing paper instead of a sketchbook as well as other tools, which are described at the end of this chapter as auxiliary tools.

The drawing devices to use depend on the nature of the subject and on the artist's preference. I prefer pencils with a range of hardnesses, including 2H, HB (or F), and B to 6B; a technical pen and, for rapid sketching, a ballpoint pen; and charcoal sticks or charcoal pencils in a range of hardnesses.

2-1 Tools for on-location sketching.

PENCILS

Pencils may be sharpened to a point or to a chisel shape (a tapered flat edge) for broad-stroke drawing (2-2). The choice of pencils depends on the artist's preference and on the best way to render the subject. With pencils, you can create both details and flat tones (2-3 and 2-4).

Sharp-Pointed Pencils

Sharp-pointed pencils are ideal for showing the outline of a subject, for drawing fine detail, and for the complete drawing of a wide variety of subjects. An HB (or F) pencil is usually

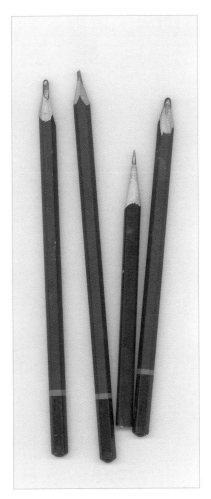

2-2 A few pencils sharpened to chisel shapes and one sharpened to a point.

adequate for showing a broad variation of depths of shade in this style of drawing. Sharpen several pencils to allow you to change when necessary to a sharp pencil as drawing proceeds. To sharpen, cut off the wood around each lead with a pocketknife to expose about ½ in. (1 cm) of lead (it's really not lead but graphite); then sharpen the lead to a point on sandpaper. Drawing 2-5 was created with strokes of a sharp-pointed pencil.

Broad-Stroke Pencils

Broad-stroke drawing uses pencils of hardnesses ranging from H to HB (or F) and from B to 6B. To sharpen a pencil for broad-stroke drawing, cut away the wood to expose about ½ in. (1 cm) of lead.

Then, with the pencil held at an angle of about 45°, rub the lead on sandpaper to produce a chisel shape with an oval end.

Broad-stroke drawing is ideal for rapid drawing, especially for showing both the textures and shapes of surfaces. When you are drawing stones, bricks, shingles, or the bark of trees by this method, you may have the impression that the pencil is almost drawing by itself.

Figures 2-6 was done with broad-stroke pencils.

Because pencil drawings smear easily and rub off onto other papers, I usually use a spray-applied fixative. Be sure the fixative is colorless and lies uniformly on the paper (test it on a scrap piece of paper before using it on your finished drawing). Apply fixative in a space that has good ventilation.

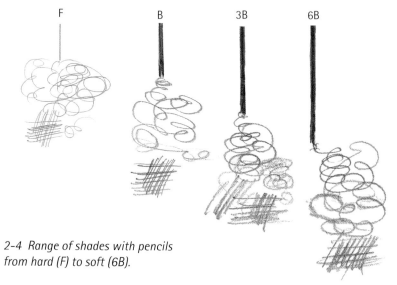

2-4 Range of shades with pencils from hard (F) to soft (6B).

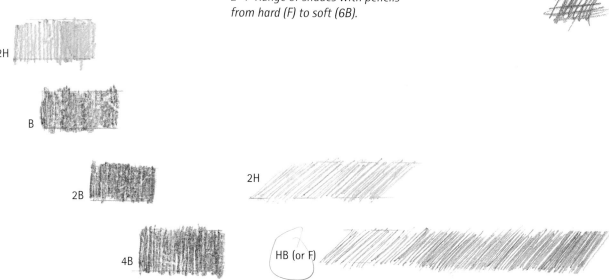

2-3 These different tones resulted from a range of hardnesses and pressures with broad-stroke and pointed pencils.

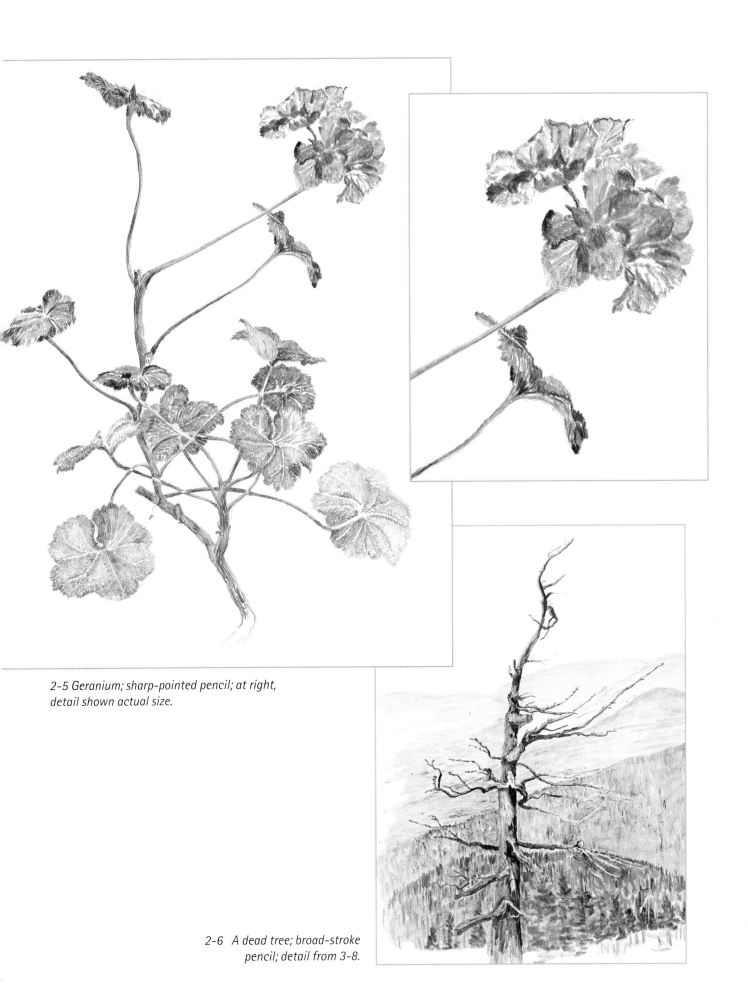

2-5 Geranium; sharp-pointed pencil; at right,
detail shown actual size.

2-6 A dead tree; broad-stroke
pencil; detail from 3-8.

Lines and Shading with Pencils

Goal: To explore a variety of lines and shading with pencils

Subject: None

Materials: Drawing paper and broad-stroke and sharp-pointed pencils H, HB (or F) and B to 4B.

Directions:

1. Using broad-stroke pencils sharpened to chisel points that are flattened to ovals on sandpaper, draw a variety of lines and rectangular areas to show the range of lines and shades obtainable.

2. Note how tipping a broad-stroke pencil onto an edge allows you to draw fine lines.

3. Using a sharp-pointed pencil of hardness HB (F), pointed by shaping on sandpaper, draw a variety of lines and note how the depth of shade varies with pressure on the pencil.

4. Using broad-stroke and sharp-pointed pencils, cover an area of several square inches (about 10 × 10 cm) with lines placed side by side. Note how the depth of shade depends on how closely the lines are spaced.

5. Cover an area of several square inches with curved lines to explore how the lines give the impression of a curved surface.

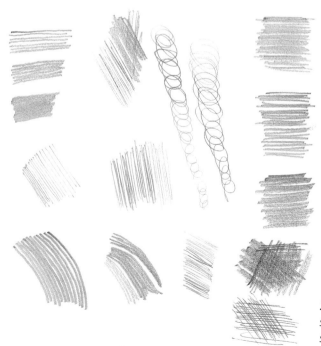

2-7 A variety of marks with sharp-pointed and broad-stroke pencils.

PEN AND INK

Steel-nib pens and waterproof ink are available, but a technical pen, a ballpoint pen, or a felt-tipped pen is much more convenient to use. For detailed pen-and-ink drawing, which is slow and meticulous work, I much prefer to use a technical pen. The scribbles in 2-8 show the kinds of lines the various pens make.

I enjoy using Rapidograph pens, especially the Rotring Rapidograph ISO pen with an ink cartridge. See 2-9 and the examples in the gallery section. The points for the Rapidograph pen come in a range of sizes. My favorites are 0.13 and 0.18 mm. The 0.13 mm point allows slightly more detail than the 0.18 mm point, but the ink in the finer point dries if a few days pass between times of use. Rapidographs require some extra care to remain in good working order.

A ballpoint or felt-tipped pen with water-soluble ink, such as the Pilot Razor Point pen, is ideal for quick sketching, as in a sketchbook. Touching a few places in a sketch with a moistened finger produces shading, making the sketch look three-dimensional (2-10). A pen drawing, with varying weights of pen lines, is shown in 2-12.

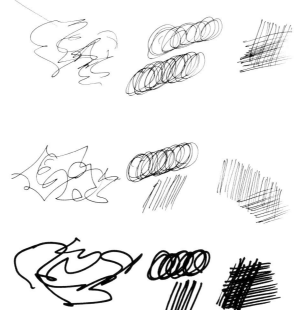

2-8 Lines made with a Rotring Rapidograph ISO (top row), a Pilot Razor Point pen (center row), and a felt-tip pen (bottom row).

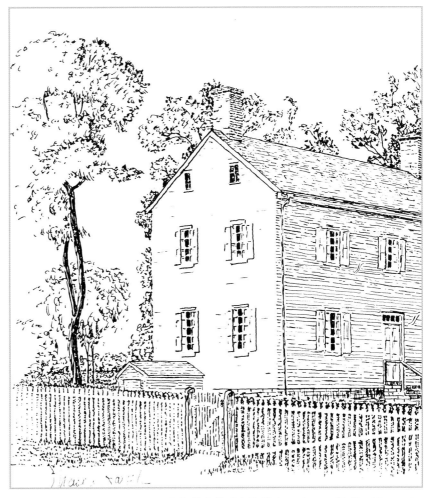

2-9 Detail of 4-3. Picture done with Rapidograph.

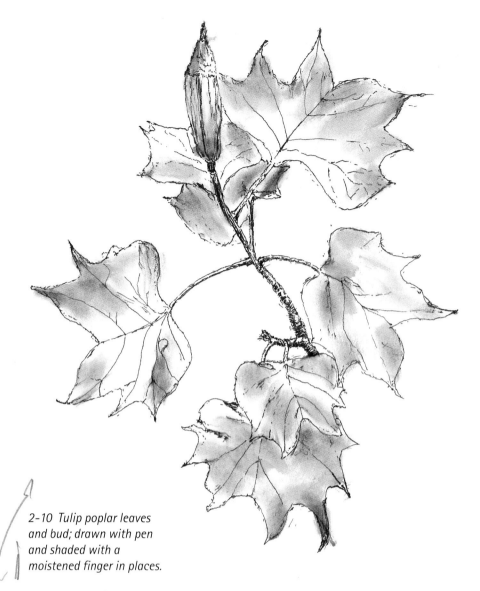

2-10 Tulip poplar leaves and bud; drawn with pen and shaded with a moistened finger in places.

Use of a Pen

Goal: To explore the use of a pen

Subject: Two or more simple subjects, e.g., two or more leaves or flowers (e.g., 2-11)

Materials: Drawing paper and a ballpoint pen or a felt-tip pen (preferably both kinds of pen).

Directions:

1. Draw the outline of one subject and add details such as solid shading or shading with side-by-side lines.

2. In the same way, draw the second subject and draw other subjects, preferably with a different type of pen.

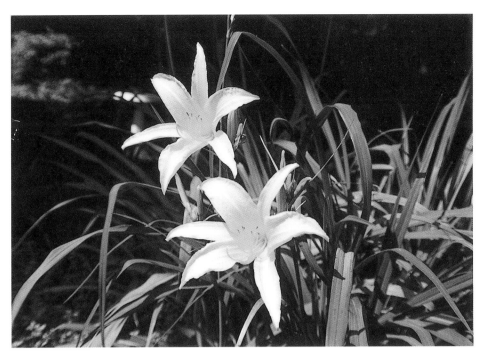

2-11 Day lilies, for use with exercise 8.

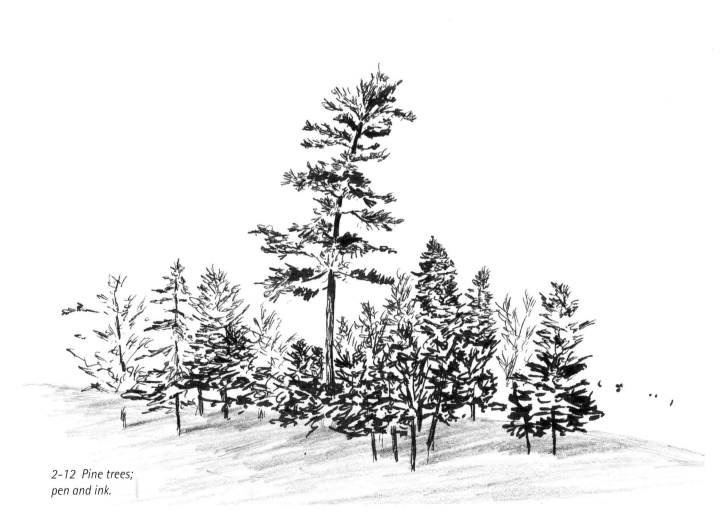

2-12 Pine trees;
pen and ink.

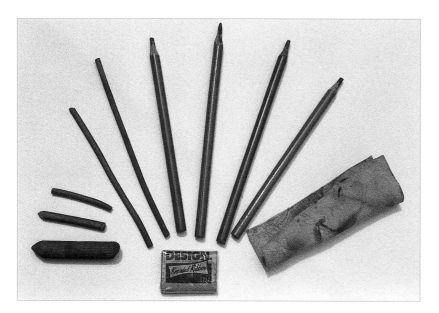

2-13 Tools for charcoal drawing include charcoal sticks and charcoal pencils, a chamois, and a kneaded-rubber eraser.

CHARCOAL STICKS AND CHARCOAL PENCILS

Charcoal is a simple drawing material, available in two forms, sticks and pencils. Sticks are made of charred willow twigs, and charcoal pencils are made by encasing crushed charcoal in wood, like a pencil (2-13). Charcoal sticks come in different widths and varying hardnesses. Charcoal pencils come in a range of hardnesses from 3B (the hardest) to 6B (the softest).

Charcoal sticks are usable as sold, but charcoal pencils must be sharpened. After removing about ½ in. (1 cm) of wood with a knife or razor blade, rub the exposed charcoal on

sandpaper to produce either a point or a chisel shape; these shapes correspond to a pointed pencil and a broad-stroke pencil.

Charcoal, a kneaded eraser, and usually a piece of chamois are the tools for charcoal drawing. Pressed against part of a drawing, the kneaded eraser lightens the area. The edge of the eraser or a point stretched out of the eraser can be used to make a light streak or a highlight in a drawing. A kneaded eraser is the best choice for removing charcoal marks and dust. Pressing the eraser onto the paper surface will usually remove the charcoal marks, but gentle rubbing occasionally is necessary. A piece of chamois rubbed over a part or all of a drawing removes most of the charcoal.

Charcoal is good for capturing the essence of a scene simply and powerfully (2-14).

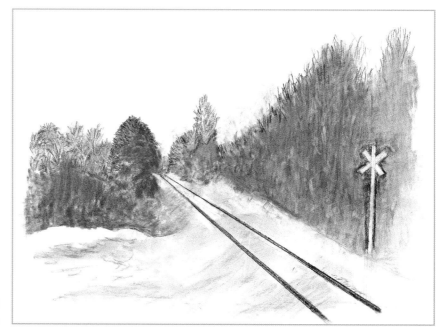

2-14 Wilmington & Northern Railway; charcoal.

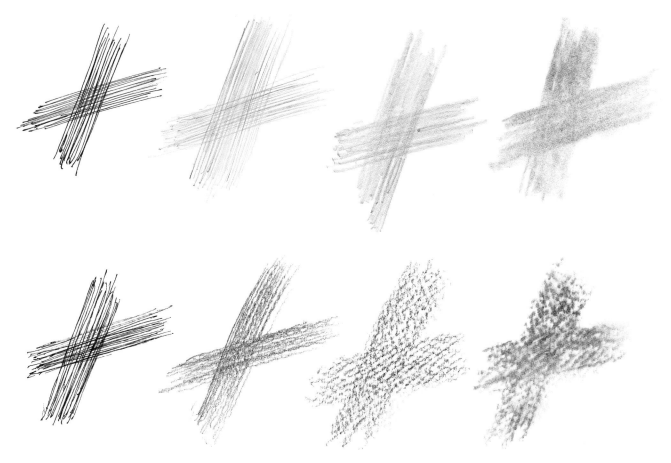

2-15 Various drawing tools on hot-pressed watercolor paper (top row) and cold-pressed watercolor paper (bottom row). Left to right: pen, sharp-pointed pencil, chisel-shaped pencil, and charcoal.

PAPER AND SKETCHBOOKS

There is a wide range of papers available for drawing, including charcoal and pastel paper, watercolor paper, Bristol board, tracing paper, vellum (a thicker kind of tracing paper), and various kinds of sketch paper. Drawing papers vary in texture or "tooth" from smooth, to medium, to rough. Watercolor papers may be hot-pressed (the smoothest), or cold-pressed, which has a slight tooth. The choice of paper should depend upon the drawing medium to be used. Bristol board, several plies of very thin, stiff, durable cardboard, comes in several smoothnesses of finish and is ideal for pencil or for pen and ink. Cold-pressed watercolor paper is excellent for charcoal because the slight tooth promotes good adhesion of the charcoal on the paper. There are also special charcoal papers available in a variety of colors. Medium or rough paper may give an interesting texture for some charcoal drawings.

Figure 2-15 shows pen, sharp-pointed pencil, chisel-shaped pencil, and charcoal lines on hot-pressed and cold-pressed papers.

White or light buff paper is usually preferred for drawings in pencil, ink, or charcoal, but for special purposes, a variety of colored papers is available.

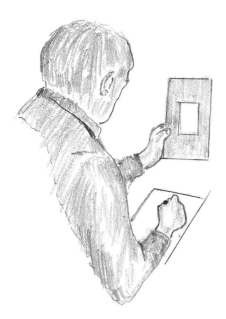

2-16 *Using a viewfinder to frame a subject while sketching.*

Papers also differ in the pulp used to manufacture them and in their acidity. The lowest-priced paper usually is made from wood pulp and is acidic. High-quality papers are made from rag pulp and are acid-free. For any artwork that is to be preserved, the best choice is acid-free paper, in order to avoid gradual discoloration and decomposition.

My choice for detailed pencil or pen-and-ink drawing is Bristol board (which is acid-free), size 14 × 17 in. (about 35.5 × 43 cm). This size is large enough for any subject (a flower or a building), and the paper also can be cut into smaller sizes.

Tracing paper is a thin, translucent paper that is useful for work on a detailed drawing. It comes in several weights, some stronger than others. A drawing can be laid out on tracing paper and then transferred to heavier paper such as Bristol board for final rendering. Another use for tracing paper arises if you believe that some change, such as the addition of a tree or a change in placement of a tree, would help your composition. A safe way to proceed without endangering extensive work is to sketch the change or addition on tracing paper and place that sketch over the main drawing. If the proposed change is unsatisfactory, you may try again with a different sketch, or you may decide not to make a change in the master drawing.

Sketchbooks are available in a variety of paper qualities and are either hardback or spiral-bound. The best ones have paper designed specifically for the medium to be used (e.g., pencil, ink, charcoal). Small sketchbooks are good for simple, quick sketches; larger ones, for detailed drawings. Two convenient sizes are 11 × 8½ in. (about 28 × 21.5 cm) and pocket-size, 4 × 6 in. (about 10 × 15 cm). Pads of paper with tear-off pages also are available for pencil or pen and ink.

VIEWFINDERS

Artists have long used a simple device called a viewfinder to aid them in choosing or cropping a subject for drawing. One form of viewfinder is a piece of cardboard with a rectangular hole whose dimensions are proportional to the intended dimensions of a drawing (2-16).

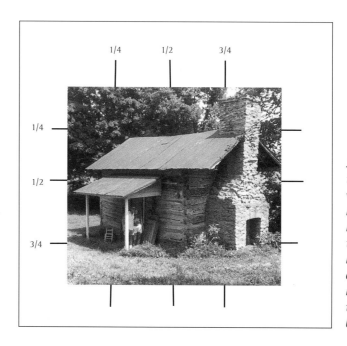

2-17 *Using the tick marks on your viewfinder, you can measure about how far down in the drawing the rooftop should be, and about how far in from the edge the chimney should be, for example.*

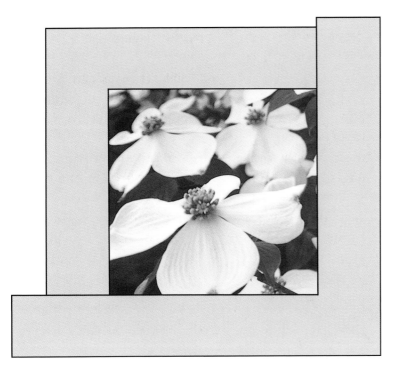

2-18 *Two L-shaped pieces of cardboard serve as a viewfinder when placed or clipped together.*

To use a viewfinder, close one eye, look at the subject through the opening with the other eye, and move the viewfinder farther from or nearer to the eye, or left or right, until you find a pleasing view in the frame.

Using a viewfinder is analogous to using the viewfinder of a camera; it eliminates distracting parts of a subject or scene and cuts off everything except what is framed. It shows you what is in the view that you have chosen, in a rectangular format. You can see if the composition looks good or not before you have drawn anything. (Of course, you could make an oval or round viewfinder too, if you wanted to make an oval or round drawing.)

In addition to helping you to select the area to draw, a viewfinder also allows you to judge the composition and the format—whether the drawing should be taller than wide or the opposite, or even square. Tick marks on the inside edges of the viewfinder, indicating ¼, ½, and ¾ of the vertical and horizontal sides, are helpful for estimating the relative lengths of parts of a subject (2-17). For example, in 2-17 you can measure how far down from the top edge of the drawing the peak of the roof should be. You can estimate how far in the chimney is, measuring from the right edge of the drawing.

Another form of viewfinder consists of two L-shaped pieces of cardboard or paper that can be placed or clipped

2-19 *If no viewfinder is available, your fingers can create one for you.*

together in front of your subject, as shown in 2-18. You can adjust the shape of the viewfinder until you find the proportions and part of the view you want to use. This form of viewfinder is particularly useful when a drawing is based on a photograph.

If no viewfinder is available, a substitute is the old-fashioned framing of a subject with two hands, as shown in 2-19.

PENCIL AS A SIGHTING TOOL FOR MEASURING DIMENSIONS AND ANGLES

In sketching, the eyes and hand can work together, as they did in the modified contour drawing, and then no viewfinder or other means of planning is needed. But simple estimates of dimensions and angles often are helpful for all sketching except the fastest. An old measuring technique uses a pencil or pen as a ruler. For me, this method helps ensure that I'll draw what I see, not what I think I see.

View the subject with one eye closed while holding the pencil or pen at arm's length, as shown in 2-20, so that the span between the point of the pencil or pen and your thumb corresponds to the length of

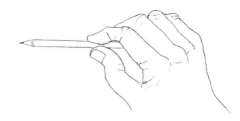

2-20 Using your pencil as a ruler, you can measure the relative sizes of parts of your subject.

part of the subject. In effect, your measuring unit is one pencil. The measured length (for example, the width of a vase) can be a standard for comparison with any other dimension in the subject (for example, the height of the vase or the width of a flower). Be sure to keep your arm extended at the same length for all measurements.

To use such a measurement in drawing, it's necessary to take into account the relative sizes of the subject and the drawing. For example, assume that the

width of the vase is two pencil lengths (measured as described) and the width of the vase in the drawing will be one pencil length (which you can measure with the pencil lying on the paper). Then each dimension you measure on the vase must be divided by 2 when you reproduce it in your drawing, to keep all the parts in the proper proportions to each other.

A pencil or pen can also serve to estimate the slope of a line in a subject, such as the angle that the roof of a building makes with the horizontal or vertical. Merely hold the pencil or pen as you did for measuring lengths (but it isn't necessary to hold the pencil at arm's length), match the slope to be estimated by aligning the pen or pencil at this angle, and then make guide marks for the same slope on your drawing (2-21). One or more light lines on the drawing can be guides for other sloping lines, if many lines have the same slope. Complicated subjects such as buildings often require more accurate measures of lengths and slopes than we have discussed here. We will describe that process in Chapter 9.

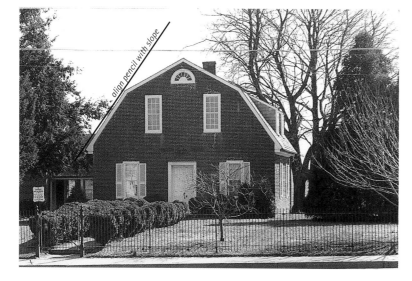

align pencil with slope

2-21 With your pencil, you can also measure the slope of lines on your subject.

CAMERA AND PHOTOS

A camera and photographs are useful—sometimes essential—tools to have along. On a trip or vacation, you may see a likely subject when the pressure of a schedule doesn't allow time for drawing. With a camera, you can capture an image of a person, animal, or bird that won't stand still long enough for drawing. There may be a scene that you come upon and admire only long enough to capture it with a camera.

To make a detailed drawing of the flower in 2-23 or the landscape in 2-22 could require many hours. The time for drawing would be too great to spend at the location. In that case, an artist would have to rely on having an exceptional memory or on one or more photographs. A photograph preserves a particular moment so you can refer to it.

A drawing done from a photograph ideally is more than just a copy of the photograph. The drawing can represent the artist's intimate experience, with emotional content that is not contained in the usual photograph.

Another advantage of working from photographs is that you can easily choose the elements of a photo that you like and leave out the ones you don't like. Sometimes, using several

2-22 A photo of a scene will help you remember the details when you are back in your studio.

photographs taken from slightly different positions (as illustrated in Chapter 9) lets you choose the best position for drawing or helps you combine parts of a subject into a good composition. In addition, two or more photos taken from slightly different positions can show details that are necessary for an accurate, complete drawing—details that otherwise could be missed.

Both color and black-and-white photos can be aids in drawing. Color photos are closer to what you see when you view the actual subject in daylight. Black-and-white photos have the advantage of already translating the multicolored subject into black and white, showing shades that may be close to the ones you desire in your drawing.

2-23 A photo comes in handy if you want to do a detailed drawing of a flower.

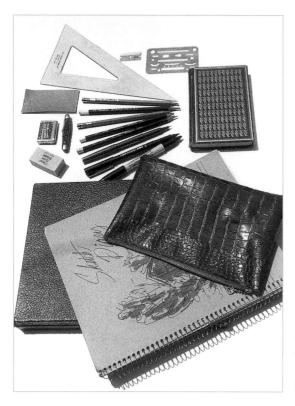

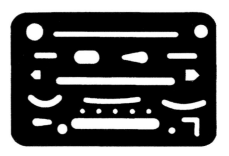

2-25 An eraser shield lets you erase within a very small area while it protects the rest of the drawing.

2-24 Useful auxiliary tools include an eraser shield (top right), razor blade, and pocketknife.

Prints are superior to slides unless you have a projector and wish to work from a picture you have projected onto your drawing paper.

Most cameras produce photographs that are suitable as a drawing resource. A camera that lets you take closeup pictures is excellent for taking some dramatic photos of flowers, portraits of people, and pictures of animals, among other things.

LIGHTING

Lighting is an important tool. The nature of lighting is critical for drawing at home or in a studio. Usually, sunlight or artificial light that simulates sunlight is best, although direct, intense light should not fall on the drawing. In the field, a bright day is usually best for drawing, provided that sunlight does not fall on your paper. For drawing in the field, the best arrangement may be to have shade on the artist but sunlight and shadows on the subject. Particular atmospheric conditions, such as fog or even the light of the moon, may be good—even inspiring—for drawing.

AUXILIARY TOOLS

A few auxiliary tools find use in many drawings (2-24):

◆ A soft or kneaded-rubber eraser is good for removing light construction lines or dots; removing small errors in a pencil drawing; assisting with the removal of a small error in a pen-and-ink drawing; or lightening the shade, removing marks, and cleaning a charcoal drawing.

◆ An eraser shield helps limit the part of a drawing to be erased, perhaps a construction line or an error. If the shield is placed on the drawing so that the place to be erased is visible through a small opening in the shield, it protects the rest of the drawing so the erasing does not extend beyond a small portion of the drawing (2-25).

◆ A single-edge razor blade may be used for careful removal of an error in a pen-and-ink drawing.

◆ Fixative helps preserve pencil and charcoal drawings, keeping them from smudging or brushing away. Read the directions and be sure to use fixative outdoors or in a well-ventilated place. Avoid getting it in your eyes..

◆ A pocketknife is handy for sharpening pencils.

◆ A small piece of sandpaper or a sandpaper block is good for sharpening pencils.

◆ A stump, which consists of a piece of paper tightly rolled into the shape of a pencil, is useful for softening and leveling shades produced by pencil or charcoal. Stumps may be purchased at art supply stores.

◆ A ruler, T-square, and triangle aid in laying out the draw-ing of a complex subject, such as a large building, where angles and perspective lines are important.

◆ A bridge, consisting of a narrow strip of wood or plastic with small "feet" at each end to raise the strip, is used to rest your arm or hand on during the drawing process, to avoid smudging the drawing.

◆ A drawing board or adjustable drawing table facilitates indoor work. The angle of a drawing board or drawing table should be nearly vertical so that the drawing will not be distorted. If you have both a table and board, your choice may be to place the board on the table and to adjust the table's angle. In the absence of a drawing table, the drawing board can be placed on a chair seat and leaned against the chair's back while you sit in another chair facing the board and its drawing paper.

◆ A light box, consisting of a translucent sheet of glass or plastic above a box containing light bulbs, is useful for copy-ing or tracing part or all of a drawing.

STUDIO

The picture of my indoor drawing area (2-26) shows that simple facilities are sufficient: a drawing table, a drawing board (not essential), a stool, a small table to hold tools, a light box, and a source of light, the window.

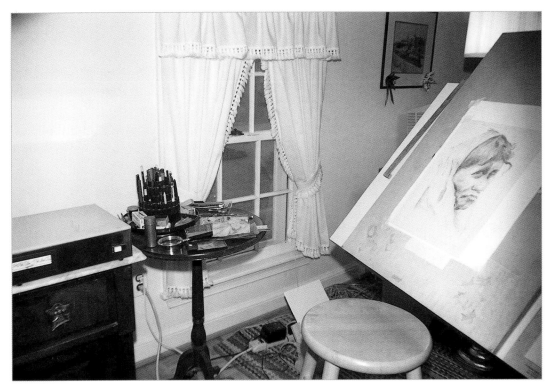

2-26 My studio. You don't need a lot of tools in order to draw.

CHAPTER 3

Composition

The term *composition* as used here refers to the manner in which the parts of a drawing are put together. Some elements of composition are: the center of interest or focal point of a work, and its unity, balance, rhythm, and pattern. Considering these concepts leads to the selection or rejection of parts of a subject and the emphasis or subordination of certain parts.

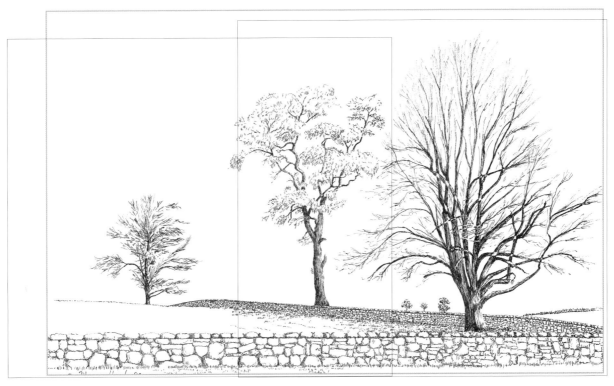

3-1 Outlines indicate two possible compositions, in addition to the drawing with all three trees that was chosen (see page 121 for enlarged drawing).

A composition is most satisfying to the artist and to any viewer if all its parts contribute to the purpose of the work. Applying this principle requires that the artist know the purpose of the work and make thoughtful selection and arrangement of every part. Selection requires that the artist avoid parts that obscure the principal subject and ones that raise questions in the mind of the viewer about the identity of any part.

CENTER OF INTEREST

The center of interest, or focal point, in a drawing directs the eye to a particular part of the subject. Because the eye can focus on only a small area at a time, we cannot see an entire scene or a drawing of a scene at one glance. The artist must compose a picture by manipulating values and selecting and arranging its parts to direct attention to the chosen center of interest. Otherwise, the viewer's eye roams without guidance from place to place.

In a satisfying drawing, the sharpest details and the strongest contrasts direct the viewer's attention to the center of interest. In addition, the existing arrangement of a scene can direct attention. Railroad tracks, a road, and a stream that recedes into the distance are examples of parts of a scene that direct the viewer's attention.

A viewfinder, described in Chapter 2, is a useful tool for selecting a scene with a satis-fying center of interest and for selecting or deleting parts of a scene to make a good composition.

The rectangular outlines on drawing 3-1 show two pairs of trees that could have been selected as the subject in place of all three trees. I chose a composition of the entire scene with three trees as the best of the three alternatives.

The artist can help focus attention by means of detail or lighting. Details that are greater in one part of a composition than in another can help direct attention to the detailed part. The intensity of light and the depth of shade

can also affect the composition by directing attention. Because sunlight and shadows vary during the day, a subject that is appealing with clear details at one time may be unsatisfactory or confusing at another time as a result of too much light or too much shadow. The artist may help the composition by "adjusting reality" to give the impression of more or less light or shadow on some parts of the work.

Emphasis on the center of interest results from either a light subject against a dark background (such as a light building against dark background trees) or a dark subject against a light background (such as a dark foreground tree with a light hill in the background).

Figures 3-2 through 3-6, drawings from the gallery at the back of the book, illustrate techniques for focusing on the center of interest.

UNITY

Unity requires that all parts of a drawing be related and fit together to express the purpose of the drawing. To achieve unity, you must subordinate anything that is confusing. This requirement applies whether your source is a still-life arrangement, a scene in nature, or a scene you find in a photograph. Unity depends

Center of Interest

Goal: To judge what factors help direct attention to the center of interest

Subject and Materials: Drawings 3-2 through 3-6, tracing paper or photocopies.

Directions:

1. Study each of the drawings.

2. Judge what factors, such as emphasizing the center of attention, help the composition of each drawing.

3. Make photocopies or tracings of the drawings. Try cutting out and moving some of the parts of the drawing, or changing their scale, darkness/lightness, or level of detail. Observe what happens to the compositions as you do this.

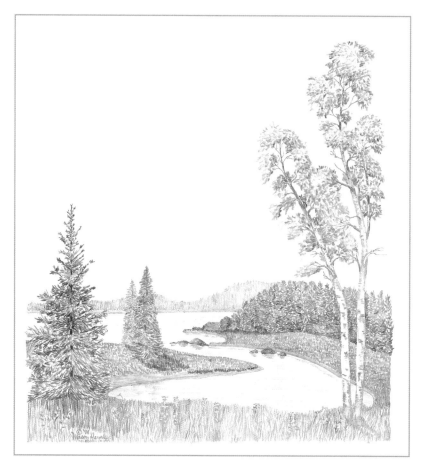

3-2 Cove of Penobscot Bay, West Brooksville, Maine; broad-stroke pencil. See Chapter 8 for details.

3-3 Hagley Museum, Wilmington, Delaware.

not only on the selection of material, but also on the relative emphasis (provided by depth of shade, detail, and lighting) that you give to the center of interest and to the parts that support the main subject. The amount of attention given to any part of a work—its emphasis or subordination—will determine whether that part supports or detracts from the unity of the drawing.

3-4 Friends' Meeting House, Wilmington, Delaware.

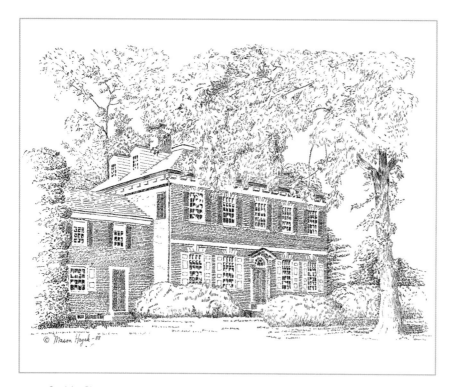

3-5 Corbit-Sharp House, Odessa, Delaware.

BALANCE

Balance, which is related to and required for unity, is the quality of establishing a feeling of restfulness in the mind of the artist or viewer. It results from having all the parts of a drawing arranged so that the center of interest and each other part receive their correct share of interest. A work lacks balance if attention is divided among several parts for any reason, such as their location or the depth of shade they have (3-7).

One way to help achieve the sense of balance is to make a preliminary study, a quick sketch with parts shaded to simulate the depth of shading you plan to use in the final drawing. Then you can make adjustments in balance in additional preliminary sketches, which lead you to selecting the values for the various parts of the actual drawing. To test the balance in a preliminary sketch, look at the balance when you turn the sketch upside down or view it in a mirror. Testing your composition by means of a preliminary sketch is particularly important for pen-and-ink work, where changes in emphasis are difficult to make in the final work.

RHYTHM

Rhythm in the final work refers to the recurrence of similar features such as trees or

3-6 John Chadd's house, Chad's Ford, Pennsylvania.

shrubbery. Rhythm pertains to accentuating parts of a subject by means of placement of details or value. Related forms tend to be more satisfying than unrelated forms.

Figure 3-8, a scene in the White Mountains, illustrates rhythm. The mountains and trees are recurring features, and the use of value and details accentuates the dead pine tree.

3-7 This drawing, based on part of the drawing of Melrose Abbey, Scotland, in Chapter 10, shows poor balance. The details and depths of shade on the right side of the picture are not balanced by the left side.

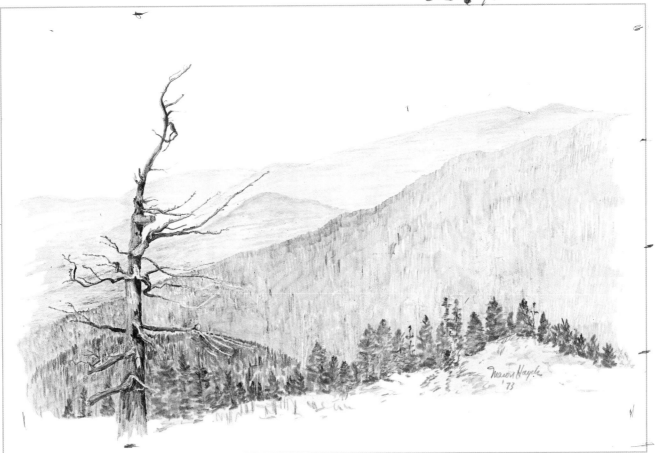

3-8 White Mountains, New Hampshire; broad-stroke pencil. The repeating shapes of the mountains and trees establish a rhythm.

PATTERN

The pattern in a sketch or drawing depends on the relationships among the various values, relative shapes, and sizes in the parts of the drawing. Pattern creates an abstract expression of the subject, depending on the direction, character, and values of strokes, which may be broad-pencil strokes, sharp pencil lines, ink lines, or solid shades or lines of charcoal. The artist's first consideration, either conscious or unconscious, is pattern for most sketches and drawings. The final pattern depends on the prominent values and shapes of the major parts and the secondary values and shapes, together with white accents, which help portray the textures of the subject (3-9).

Efforts to create a unifying pattern may be unnecessary for a quick sketch that is intended only to capture a fleeting scene.

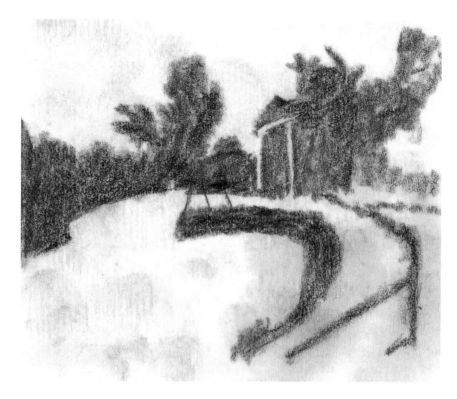

3-9 *This broad-stroke pencil sketch is an example of pattern, taken from drawing 3-3.*

REPETITION AND DIFFERENCE

The composition of a drawing depends on both repetition of and difference among the parts of the drawing. Repetition is related to unity. Consideration of depth of shade, scale, and texture is essential to achieve the purpose of a drawing and to produce a pleasing composition (3-10). For example, think of two or more people, trees, or buildings in a drawing. Significant repetition of scale and shading are essential to show the relations among the parts, to achieve some realism, and to assure the absence of questions in the mind of a viewer. Differences are justified only to achieve a particular result. Two people drawn to a different scale (e.g., one twice as big as the other) or with a significantly different depth of shade would attract attention or give a particular message.

Differences among parts of a drawing, as with light against dark or dark against light, can help focus the viewer's eye on the center of interest. For example, a dark tree drawn against a light background of a hill or of other trees forces the eye to concentrate on the dark tree in the foreground.

The careful repetition of features within a drawing, such as dark against light for a flower, aids composition by attracting the eye.

Evergreens, such as pine trees or shrubbery, and trees in full leaf are living examples of the effects of light against dark. The shapes of branches, leaves, and needles and the relations among the parts also are defined by the contrasts of light against dark. Care in shading produces a drawing of a particular tree, not a nondescript tree (3-11).

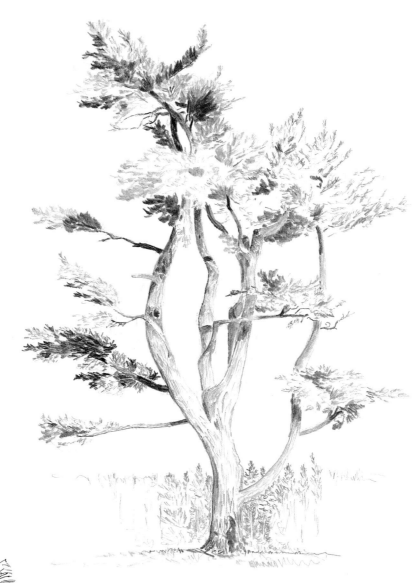

3-11 Pine at Machias, Maine; broad-stroke pencil.

3-10 Repetition of texture in a drawing of a palm tree. Ocean Gallery, St. Augustine, Florida; pen and ink.

WHITE SPACE

The manipulation of white against dark can have a profound effect on composition. For example, surrounding a white area with black, or a black area with white, can direct attention to the center of interest. The contrast makes the white area appear especially white or the black especially black.

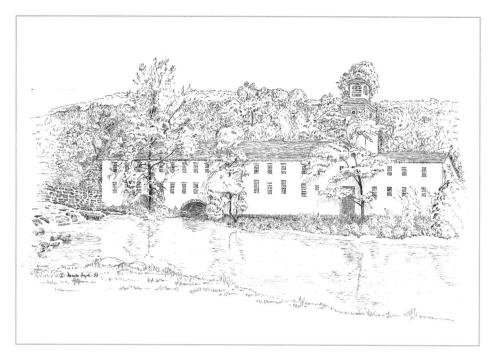

3-12 Walker's Mill, Wilmington, Delaware; pen and ink. White-black contrast focuses attention on the center of interest.

Such use of white space can be important in parts of a drawing that require special attention.

The drawing of Walker's Mill (3-12) has a large area of white, and the contrast of the white against the black calls attention to the center of interest. To moderate the strong effect of white against dark, vignetting of the edges of a drawing (feathering the edges to a light shade) avoids drawing attention away from the center of interest to the edges.

In Figure 3-13, a portion of another drawing, vignetting of the fence and the foliage of the tree may be seen.

3-13 Vignetting may be seen in the tree and fence (detail of drawing 4-3 of Ministry's Shop, Shaker Village, Pleasant Hill, Kentucky; pen and ink).

exercise 10

Aspects of Composition

Goal: To recognize factors in an effective composition

Subject and Materials: Figures 3-2 through 3-6.

Directions:

1. Examine the five drawings to look for various factors (unity, balance, etc.) that aid the composition of each drawing.

2. Examine the same drawings to look for problems caused by the lack of good use of the principles of composition.

CHAPTER 4

Perspective

Perspective is the representation of a three-dimensional object on a two-dimensional surface. If you follow the rule of drawing what you see instead of what you think you see, you probably will find that you are using the principles of perspective. These principles were systematized during the Renaissance, although people from earliest times had some way of representing three dimensions in their drawings.

EXAMPLES AND CONCEPTS

If you draw a house or barn as it looks from a position in which you see the part of the roof and two of the sides, the drawing will look realistic only if you accept the fact that the top edge of the roof and the line that marks the bottom of the building will not be exactly parallel on your drawing (4-1). If these two lines on your drawing were extended far enough, they would meet at a point called the vanishing point, even though that point might not be on your paper, although in reality, we know the roof line and the bottom of the house are parallel. The principles of perspective

are valuable guides for realistic drawing, but generally, rigid adherence to the principles is not necessary. Drawing what you see is critical, and knowing the principles of perspective helps you achieve realism. The edges of the drawing paper, both horizontal and vertical, can serve as references for drawing, and the angles of parts of the subject can be estimated by the method described in Chapter 2.

Figure 4-1 has lines extending from parts of the house. The lines are actually parallel on the house (for example, all the lines labeled 1 are parallel), but in the photograph these lines are not parallel and would meet if extended far enough (see 4-8). Notice espe-

cially the lines marked 1. The slope of the top of the roof contrasts with the almost horizontal line marking the bottoms of the front windows. The lines marked 2 show other parts of the house that are not parallel to each other in the photo, even though they actually are parallel on the house. The two lines marked 3 show the angles of the left and right ends of the roof.

As another example of the effects of perspective, look at the cups in 4-2. The rim of a cup is circular if you look straight down at the cup, but the shape of the rim appears elliptical if you look at it from a lower angle, and finally looks like a straight line as you view the cup from its side.

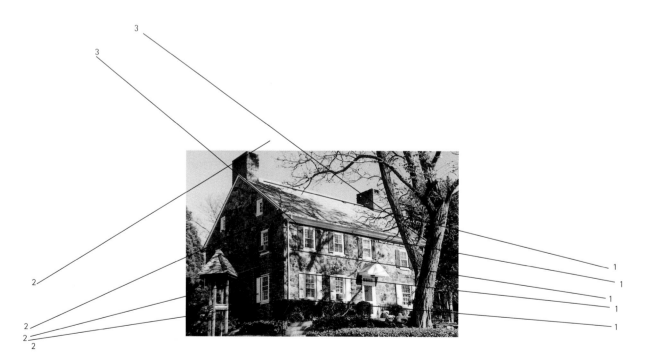

4-1. Lines that are actually parallel on a house aren't parallel in this photo. To draw them accurately, you would have to consider the effects of perspective.

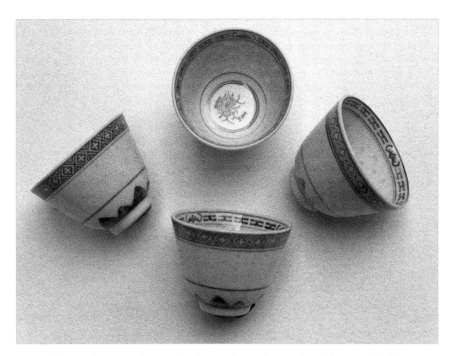

4-2. Effects of perspective on the shape of a cup's opening. When you look straight down on it, the cup opening looks circular. As it is turned to the side, the opening looks like an ellipse. Seen from the side only, the opening looks like a straight line.

The principles of perspective show how to take into account your point of view and give you some guidelines for drawing objects as they appear, even though that appearance is different from reality. Without getting too technical, we'll explain the basic principles in this chapter. A few definitions will be helpful:

◆ The line at your eye level that is the farthest away from you that you can see from a certain point of view is called the horizon line. Outdoors, this may be the horizon itself. If it isn't visible, the horizon line can be imagined as a horizontal line at your eye level. The horizon line is always at the eye level of the viewer. All the vanishing points of horizontal lines meet at the horizon line.

◆ An imaginary line going from your eyes to the subject is called the line of sight.

◆ The picture plane is an imaginary area occupied by the picture surface, perpendicular to your line of sight. It can be thought of as a window that you look out of when your body is parallel to the window.

◆ If you shift or turn your body even a little, the picture plane and your line of sight change also.

◆ If you are looking at an object from an angle, horizontal lines above your eye level appear to slant downward; horizontal lines below your eye level appear to slant upward.

APPARENT DECREASE OF SIZE AND SPACING WITH DISTANCE

The apparent size of an object decreases as the viewer's distance from the object increases. Thus, distant high mountains may appear smaller (as well as paler and less distinct) than a nearby tree. A

4-3 Ministry's Shop, Shaker Village, Pleasant Hill, Kentucky; pen and ink. The distant trees and the distant fence appear much smaller than the nearby ones.

distant tall tree may appear shorter than a nearby small tree. If you look at two trees of equal size, the far one will look smaller than the near one.

The apparent distance between objects diminishes as your distance from the objects increases. The spaces between objects that actually are equidistant from each other, such as a row of equally spaced trees or uprights on a fence, diminish as the objects get farther away from you.

But don't be alarmed if this sounds too technical; making a drawing of objects of diminishing sizes and placing them closer and closer together as they get farther away from you only requires that you draw what you see. The drawing of a Shaker building shown in Figure 4-3 illustrates the principle of apparent sizes decreasing with distance. The distant fence appears much smaller than the nearby fence, and the distant trees are smaller than the near ones. See Figure 4-4 for another example of decreasing size.

AERIAL PERSPECTIVE AND INTERPOSITION

In general, objects that are nearby are more distinct, more colorful, and brighter than objects that are far away. This is the effect of the air in between you and the objects; air diffuses the light traveling from the objects as it bounces back to you. It is called aerial perspective. In addition, we know from experience that an object whose outline is partly covered by another object is probably behind the object whose outline is not covered. This perspective cue is called interposition. In 4-4, we know the pine trees on the left are in front of the mountains, because the pine tree shapes interrupt the shapes of the mountains.

TRUE AND APPARENT SHAPES

A surface appears in its true shape only if that surface is at a right angle to your line of sight. The photogaph of cups (4-2) at the beginning of this chapter illustrates this principle. If you look directly down at the cup, your line of sight is perpendicular to the rim's surface, and thus the rim looks circular.

If you stand with your body parallel to the side of a house, so your line of sight is perpendicular to its side, the side looks rectangular. Once you are at an angle to the side of the house, the side doesn't look like a rectangle anymore.

You can see other examples of the effects of perspective by

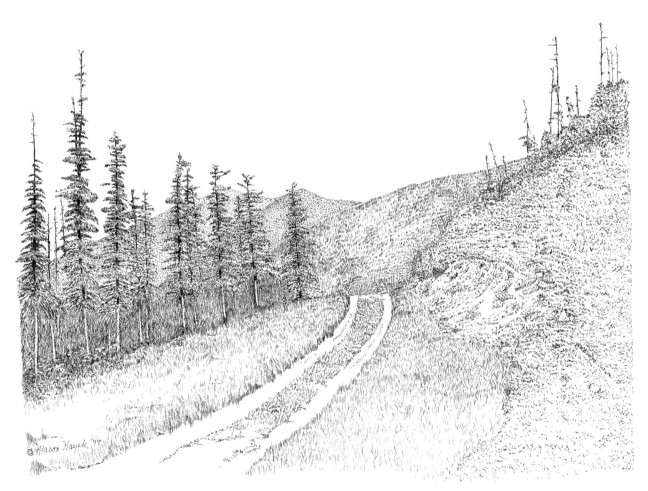

4-4 Wildcat Mountain Road, New Hampshire. Several perspective cues can be seen here: converging lines; trees decreasing in size as they get further away, and the texture of the scene becoming less noticeable in the distance.

looking at your fingers when your palm is up and your fingers are bent so that the tips are up towards you. The shape you see is nothing like the shape of your hand if you look at it when it is extended out flat before you. When your fingers are bent towards you, their images are foreshortened.

VANISHING POINTS

A vanishing point is a point on the horizon line at which the extensions of any two or more parallel lines on a subject appear to converge. In 4-5, a scene with one vanishing point, the railroad tracks appear to come together to one point, the vanishing point. The parallel lines of trees also come together at this point. In this photo, the picture plane is parallel to the nearest edges of the railroad ties and perpendicular to the rails. Such a situation can be laid out in your sketch using one-point perspective (one vanishing point). Figure 4-6 shows another scene that only required one vanishing point to capture it, although it was drawn from a station point at an angle to the railroad tracks.

Two vanishing-point (angular) perspective applies when the viewer is at a point at which two planes of a rectangular object such as a building or room are visible; in this case, the object is turned at an angle to the viewer and no side is parallel to the picture plane. The parallel lines on the object can be extended in two directions to two vanishing points on the horizon line.

Figure 4-7 shows how your station point affects the shape of the cube you see. The drawing of the Christian Church in Kirksville, Kentucky (4-8 and 4-9) was done using two-point perspective.

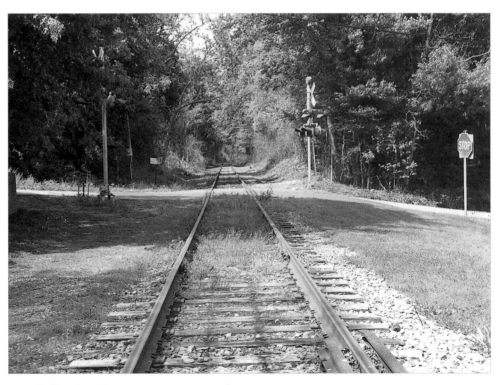

4-5 Railroad tracks seem to retreat towards one vanishing point in the distance.

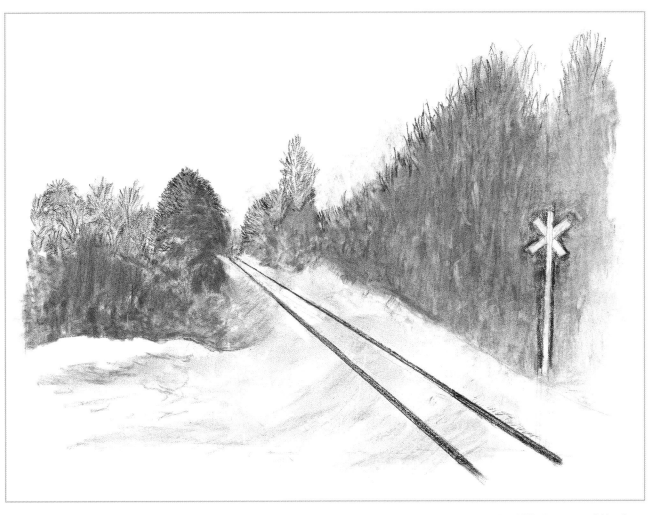

4-6 The Wilmington and Northern Railway; the rail lines vanishing in the distance can be seen in this charcoal drawing.

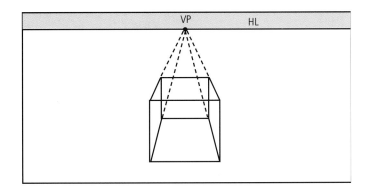

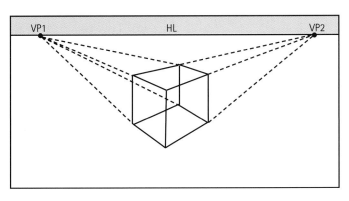

4-7 A cube seen in parallel perspective (one vanishing point) and angular perspective (2 vanishing points).
HL = horizon line. VP = vanishing point.

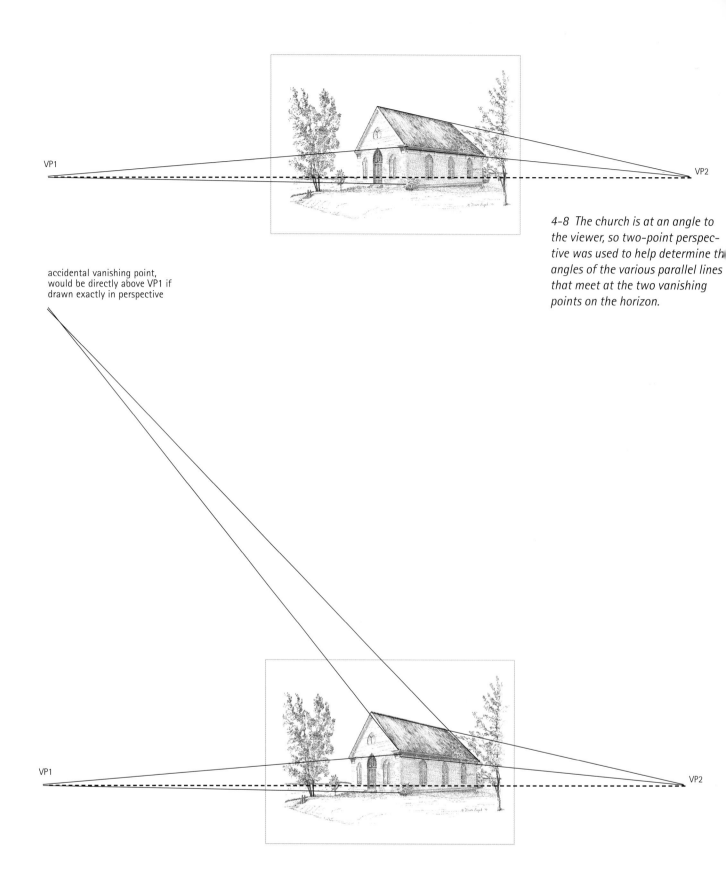

VP1

VP2

4-8 The church is at an angle to the viewer, so two-point perspective was used to help determine the angles of the various parallel lines that meet at the two vanishing points on the horizon.

accidental vanishing point, would be directly above VP1 if drawn exactly in perspective

VP1

VP2

4-9 The roof, which is an inclined plane at an angle to the sides of the house, has its own vanishing point, an accidental vanishing point where the lines parallel to its sides converge. The accidental vanishing point is on the same vertical line as one of the two vanishing points on the horizon. The roof's lines aren't parallel to the lines that end in either of the other two vanishing points. Dashed line is horizon line.

In both of the above cases (one- and two-point perspective), the picture plane is perpendicular to the ground. The vertical lines of a low building, such as a house or barn, appear vertical in these cases.

But if you look downward at objects from a balcony above a building or above a room, the vertical lines would no longer remain vertical, but would come together in a third vanishing point, below the horizon line, which is probably off the paper. To draw this accurately we'd need to use 3-point perspective. For a tall building seen from below, the lines that appear vertical near eye level also recede to a third vanishing point. But for most drawing situations you won't need 3-point perspective.

What happens to planes on an object that aren't parallel to lines that end at the main vanishing points? An example of this is the sloping roof in Figure 4-9, opposite. Lines drawn from its two sides come together in their own vanishing point, called an accidental vanishing point, which, if drawn with architectural accuracy, lies on a vertical line above one of the vanishing points of the object drawn in 2-point perspective.

The rules of perspective apply to lines in landscapes and seascapes as well as to buildings and smaller objects and parts of the body. Parallel lines that recede into the distance, such as the sides of a road, a path, or a stream, converge at a vanishing point. The lines of waves on a body of water also converge at a vanishing point on the horizon.

4-10 Drawing done in almost parallel perspective; front of house is almost parallel to the picture plane and looks rectangular (Pleasant Hill Water House, Pleasant Hill, Kentucky).

Principles of Perspective

Goal: To utilize the rules of perspectives in drawing a building

Subject: Figure 4-11, a photo of a barn; or a photograph of a similar simple building in which you see two sides of the building and part of the roof; or a simple building for on-location drawing

Materials: Choice of broad-stroke or sharp-pointed pencils, a pen, or charcoal sticks or charcoal pencils and auxiliary tools.

Directions:

1. Position yourself so you see two sides of the building if you are on location, or use the photo.

2. Outline the subject, using the modified contour method.

3. Lay out the drawing and correct the outline as necessary to take into account two-point (angular) perspective and the accidental vanishing point needed to show the top and sides of the roof. Include the bottom of the building and the surrounding area.

4. Complete the drawing.

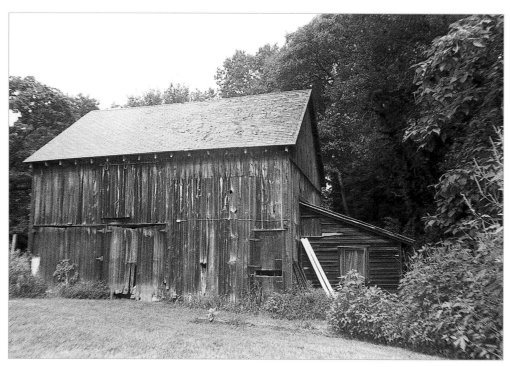

4-11 A barn, shown at a slight angle to the viewer.

CHAPTER 5

Techniques with Various Tools

Over the years, as they work, artists develop or learn

techniques that give them the satisfaction they want

from drawing. None or few of the methods of making

sketches or detailed drawings are unique to any artist;

they simply work well for him or her. Some techniques

and methods are best for quick sketches and others for

more detailed drawings. Some are good for both.

This chapter deals, first, with the use of tools for sketching and drawing. I've included some samples of sketches and drawings as illustrations without comments. For other drawings, I've shown their execution step by step.

SHARP-POINTED PENCILS

Most sketching and drawing with sharp-pointed pencils requires only two grades. HB (also called F) is good for a finished sketch or drawing showing a variety of shades, shapes,

and textures. A hard pencil, H or 2H, is useful for faint lines or for laying out a drawing where the faint dots or lines will be covered with lines of a softer pencil.

To show areas of single or graded shades with HB or F pencils, you need to draw lines close together or farther apart, with pressure applied as necessary to vary the depth of shade. Straight or curved lines show the shapes of the subject (see Chapter 2, Exercise 8).

In the rendering of any sketch or drawing to be made with pencil, pen, or charcoal, application of the deepest (darkest) shades first helps define the range of shades to be used. Then the other shades can be related to the deepest shade.

Because placing lines carefully requires considerable time, the use of sharp-pointed pencils is generally limited to drawing outlines or to doing slow, detailed work, either on location or in the studio (see 5-1, for example).

HB Hard
H or 2H = Soft

See p²²

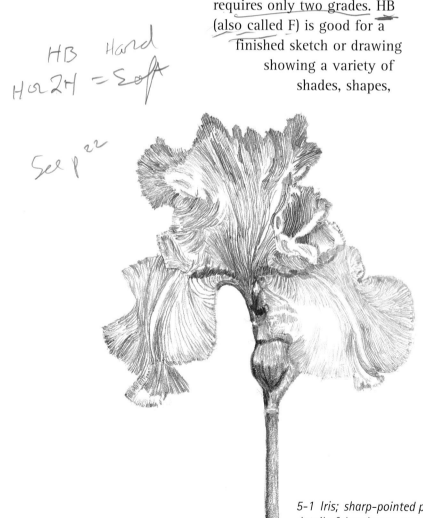

5-1 Iris; sharp-pointed pencils; detail of drawing on page 107.

Sharp-Pointed Pencil Drawing

Goal: To make a drawing with sharp-pointed pencils

Subject: A simple subject, such as a flower or leaf that requires a variety of both shades and shapes (could be a photograph)

Materials: A 2H pencil sharpened to a point and one or more F (or HB) pencils sharpened to points, sketchbook 8½ × 10 in. (21.5 × 25.5 cm) or larger or drawing paper, a bridge, and fixative.

Directions:

1. Using the 2H pencil, lay out the drawing by using the modified contour method.

2. Using lines only, draw the subject, varying the depth of shade by changing pressure on the pencil and by spacing the lines close together or farther apart. Show the shapes of the subject by varying the shapes of lines, straight or curved. Work from the front of the drawing to the rear. To prevent smudging of the drawing, use a bridge during the work and apply fixative to the completed drawing.

5-2 Day lily.

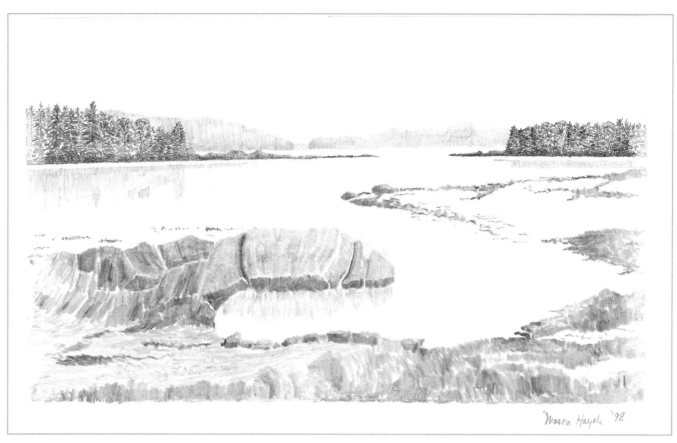

5-3 Cove, Penobscot Bay, West Brooksville, Maine. Broad-stroke pencil.

BROAD-STROKE PENCILS

Broad-stroke pencils may be of grades 2H, HB (F), and B to 6B. For broad strokes, sharpen the pencil to a chisel point (see Chapter 2). Hold the pencil with the flat area evenly on the paper; then draw down the pencil to produce a uniform, broad line. The depth of shade (darkness) of the line depends mostly on the grade of pencil and partly on the pressure applied. Draw down the stroke in a uniform way to produce a narrow area of uniform shade. To make the shade deeper on one side than the other for parts of some subjects, tilt the pencil slightly to one side. To make a narrow line, tilt the pencil so that only the tip edge contacts the paper.

The variety of strokes that are possible—uniform, graded, and sharp-edge—can provide an impression of reality. Sometimes you may find that breaking a broad area of parallel pencil strokes with a few diagonal strokes reduces the monotony (5-3).

Broad-Stroke Pencil Drawing

Goal: To make a drawing with broad-stoke pencils

Subject: A simple subject such as a leaf, flower, or stone that requires a variety of shades and shapes (could be a photograph)

Materials: A 2H pencil sharpened to a point, plus a 2H and one to three other pencils of hardness in the range F (HB) and B to 5B, a sketchbook of dimensions at least 8½ × 10 in. (21.5 × 25.5 cm) of drawing paper, a bridge, and fixative.

Directions:

1. Use the pointed 2H pencil to outline the subject by means of the modified contour method.

2. With the chisel-shaped surfaces of the pencils, draw the subject, selecting the pencils and choosing the pressure you put on them to produce the appearance of realism. Work on the deepest shade first to help you in the selection of lighter shades. Work from front to rear.

3. To prevent smudging of the drawing, use the bridge during the work, and apply fixative at the end.

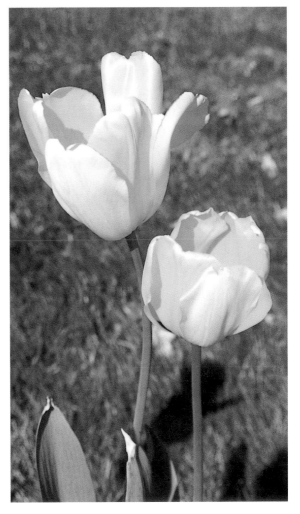

5-4 Tulips.

Pen-and-Ink Drawing

Goal: To make a drawing with pen and ink

Subject: A simple subject such as a leaf, flower, or stone that requires drawing a variety of shades and shapes (could be a photograph)

Materials: A 2H pencil sharpened to a point, a felt-tip or ballpoint pen, a fountain pen, or a technical pen, and a sketchbook of dimensions at least 8 × 10 in. (20 × 25.5 cm) or drawing paper suitable for inking.

Directions:

1. With the 2H pencil, outline the subject in light lines, using the modified contour method.

2. Using one of the pens, draw lines as for the pointed-pencil drawing in Exercise 12, except that all lines should be drawn at uniform pressure. Start with the deepest shade to aid the selection of the range of shades. Work from the front to the rear of the drawing.

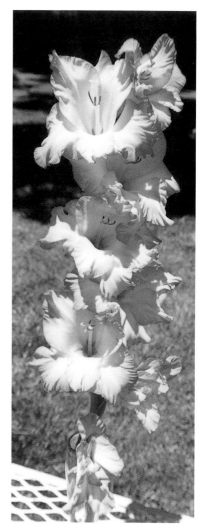

5-5 Gladiolus.

PEN AND INK

The choice of pen depends on the purpose for which you will use it. For quick sketches, a ballpoint, felt-tipped pen, or fountain pen is useful. Any one of these is convenient to carry for on-location sketching. A sketch made with any of these pens requires only a few minutes. Several sketches in this chapter and in other chapters illustrate the use of such pens. As described in Chapter 2, if you use ballpoint pen containing water-soluble ink, shading may be done by simply touching places with a moistened finger.

For detailed drawing on the spot or in the studio, the choice is between steel-nib pens with waterproof ink and technical pens with ink or with an ink cartridge. My favorite is the Rotring Rapidograph ISO technical pen with an ink cartridge and 0.13 or 0.18 mm point.

Figure 5-6, as well as the illustrations in Chapter 2 and elsewhere in the book, show examples of sketches and drawings done in ink with various kinds of pens.

5-6. Two young white oaks,
Poconos, Woodledge;
pen and ink.

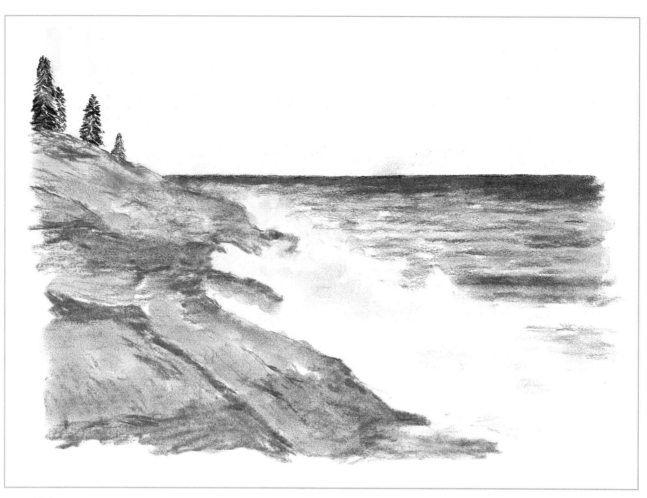

5-7 Maine coast; charcoal.

CHARCOAL

Charcoal comes in the forms described in Chapter 2, sticks of various thickness or compressed charcoal encased in wood, like a pencil lead. Drawing with charcoal is both easy and fast. It involves drawing lines or narrow areas, depending on the width of the charcoal stick or pencil, and then spreading, blending, and smoothing the charcoal particles on the paper with your fingers or with a stump (a tightly rolled, pencil-shaped cardboard tool). Charcoal work requires a paper that has some tooth; lines on smooth paper are hard to spread and are hard to remove. Charcoal paper, pastel paper, and cold-pressed watercolor paper all work well with charcoal.

To lay out or plan a drawing before shading, use a charcoal pencil or the chisel-pointed edge of a charcoal stick. A soft charcoal pencil, for example a 4B or 6B, is better than a harder pencil because the lines made with a soft pencil are easy to remove if necessary.

Varying the way the charcoal is applied on the paper—by drawing the charcoal down, up, or across the paper or even covering areas by using the side of a charcoal stick—can produce a range of blacks from faint to deep. A medium tone results from rubbing the charcoal into the paper. Shading results from drawing a deep-black area and then smoothing and blending toward light areas or untouched paper. Using a stump may produce a shade more accurately than using fingers, so a stump is

superior where accuracy is necessary.

Because of the nature of charcoal on paper and the ease of smudging or otherwise damaging a drawing, it usually is good practice to start drawing at the upper left of your paper if you are right-handed or at the upper right of your paper if you are left-handed. The idea is to avoid crossing over the finished work as much as possible. After outlining the main shapes, try to lay down the deepest shade. Do this early in the process, to help guide you in selecting the range of shades. It may be necessary to use a bridge (see Chapter 2). The application of fixative must be the last step.

Pressing a kneaded-rubber eraser into the charcoal on the paper is a means to produce highlights in a drawing, to reduce the depth of shade, and to remove part of a drawing for a correction. The kneaded-rubber eraser also can be stretched to a point for use in producing a narrow highlight. To correct an error or to improve a drawing, you can remove part of a drawing by rubbing it with a piece of chamois.

The following step-by-step drawing of a subject in charcoal (5-8 to 5-11) illustrates the techniques involved in working with charcoal. The subject is a scene near Machias, Maine.

5-8 The first step was to draw an outline of the scene, using a 5B charcoal pencil that was sharpened to a point.

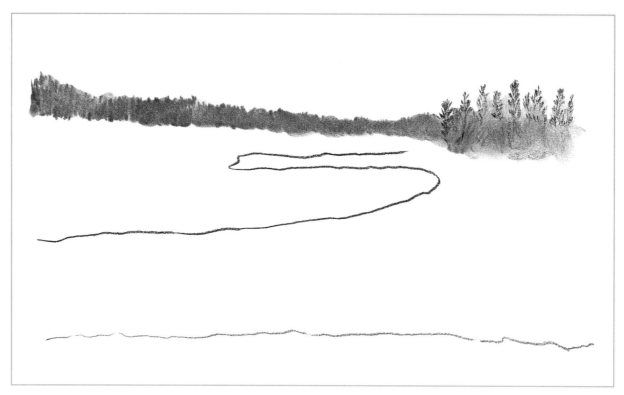

5-9 After outlining, the drawing was begun in the upper left corner to minimize smudging (a left-handed person would begin in the upper right). Touching or rubbing the charcoal lightly reduced the depth of shade in a few places. The 5B charcoal pencil was good for drawing the trees on the right side.

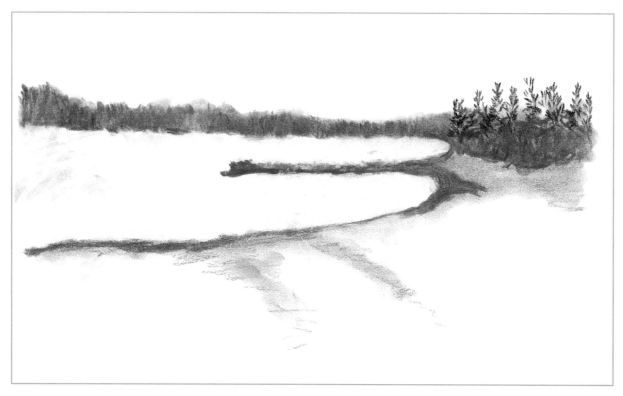

5-10 Drawing continued with deep black in the foreground; some parts were weakened by touching and rubbing.

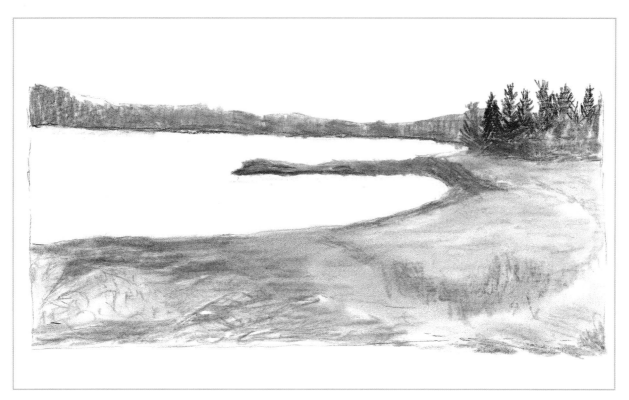

5-11 I deepened the black of the trees on the right side and filled the nearby shore with both deep and light shades to achieve a realistic look.

exercise 15

Charcoal Drawing

Goal: To make a drawing with sharp-pointed pencils

Subject: A simple subject, such as a flower or leaf that requires showing a variety of both shades and shapes

Materials: A 2H pencil sharpened to a point and one or more F (or HB) pencils sharpened to points, sketchbook 8 × 10 in. or larger or drawing paper, a bridge, and fixative.

Directions:
1. Following the technique described in this section of the book, draw the subject in charcoal. Work from the front of the subject to the rear.

2. Use the bridge to prevent smudging while you work. Use a kneaded-rubber eraser to lighten spots where necessary.

3. Use fixative to protect the completed drawing.

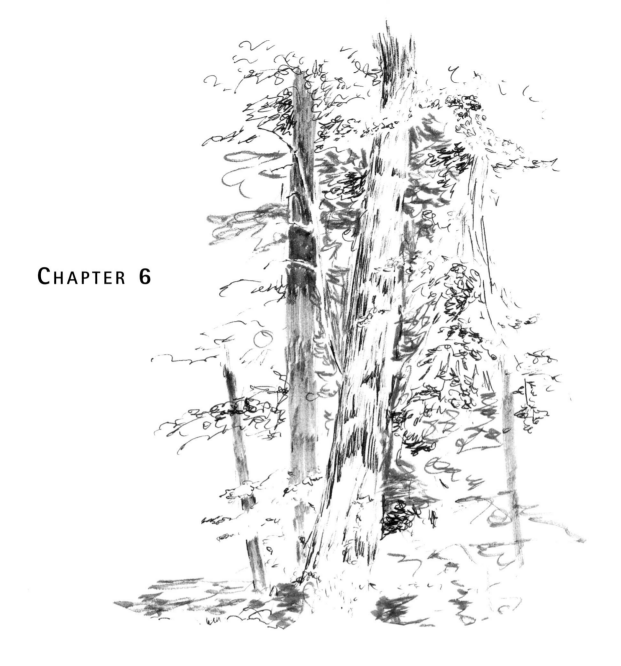

Executing Sketches

The basis of any sketch or detailed drawing, unless it is copied, is a modified contour drawing, done by watching the subject and making only quick glances at the paper as the hand draws what the eye sees, as described in Chapter 1. Several factors may be involved in choosing a subject, including inspiration, motivation, need or purpose, and the time available for sketching or drawing.

You may want to make a quick sketch of a person or scene to help you remember an experience. You may sketch a flower, tree, or person for the satisfaction of capturing quickly on paper what you see clearly, to help you capture for your memory a fleeting subject or an event. A sketch may be preparatory to a more detailed drawing. Whatever the reason, sketching involves coordinating the hand with the eyes.

6-1 Quick contour sketch of pansies, done in pen with water-soluble ink, has a few shaded areas made with a moistened finger.

QUICK SKETCHES AND DETAILED SKETCHES

A quick sketch is one you execute in a minute or two or at most in a few minutes; done when time is very short, it lacks details that a longer sketch would include. Figures 6-1 through 6-5 are examples of quick sketches that required 2 to 5 minutes to do. When you do a quick sketch, try to concentrate on the general shapes and the relationships among them; don't attempt to get too detailed. If you have time, indicate some lights and darks as well. Many of the principles of detailed sketching given in this section apply equally to quick sketching. For example, any medium is useful for sketching.

A pleasing sketch begins with consideration of design and pattern, not the assessment of details. You make subsequent

6-2 O'Hare Airport, Chicago; ball-point pen.

6-3 Sketch for a detailed drawing.

decisions quickly, including the size of the sketch (possibly determined by the size of a sketchbook page); the portion of the subject to include; the way to compose the sketch in order to draw attention to the center of interest; the amount of detail to include (for example, the outline only of a flower or details of the petals); and tools you will use (sharp-pointed or broad-stroke chisel-shape pencil, pen, or charcoal).

Sketching, even if quick, benefits from some accuracy. Measuring lengths and angles with the use of a pencil or pen, as described in Chapter 2, provides an easy route to accuracy. For example, if the subject is a tree, estimates of the diameter of the trunk, the distance between the ground and the lowest branch, and the relative dimensions of the mass of foliage can help produce a realistic sketch.

A pen, as used for 6-2, or a pointed pencil (6-3) is the tool for outlining a subject and perhaps shading by scribbling in one or more areas or using side-by-side lines.

Broad-stroke pencil drawing, as seen in 6-4 and 6-5, allows you to show details, textures,

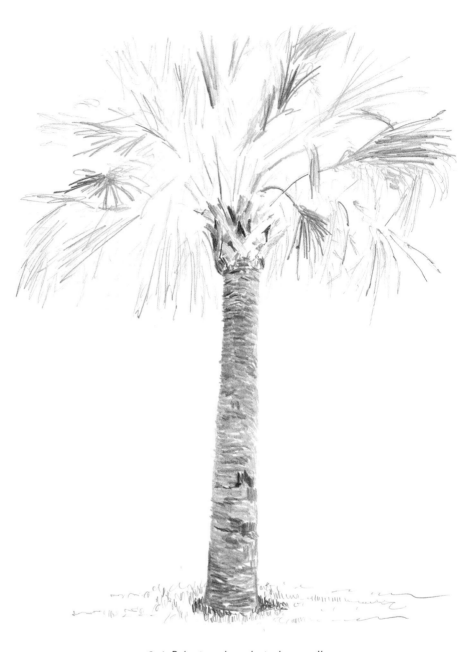

6-4 Palm tree; broad-stroke pencil.

and a range of shades. Broad-stroke pencil drawing also has the advantage of covering areas rapidly, which is useful when doing a quick sketch.

Charcoal is a medium that serves well for either sketches or for more detailed drawings.

A pen with water-soluble ink is excellent for outlining a subject. Then you can indicate three dimensions by touching some of the lines with a moistened finger to shade a few

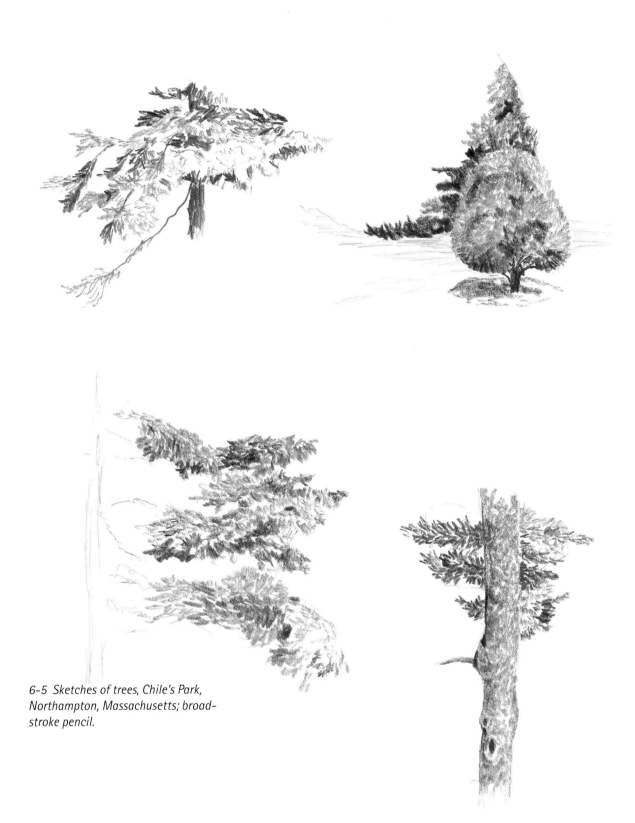

6-5 Sketches of trees, Chile's Park, Northampton, Massachusetts; broad-stroke pencil.

areas (6-6). I like the convenience of carrying a small sketchbook, say about 6 × 4 in. (about 15 × 10 cm), and one or two pens with water-soluble ink for quick sketches. A larger sketchbook, say about 11 × 8½ in. (about 28 × 21.5 cm), allows for larger sketching, a greater choice of subjects, and lets you create sketches of considerable detail, which approach or become drawings.

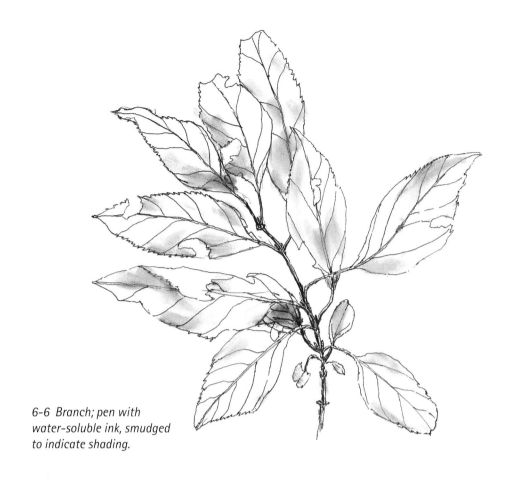

6-6 Branch; pen with
water-soluble ink, smudged
to indicate shading.

6-7 Longwood Gardens water lily;
broad-stroke pencil.

Sketching

Goal: To practice sketching

Subject: A branch of a bush or tree with flowers and leaves, or a flower, such as those pictured in 6-8 and 6-9 (could be a photograph)

Materials: Any pencil, pen, or charcoal described in this chapter; a sketchbook; and a kneaded-rubber eraser.

Directions:

1. Using the techniques described in this chapter, sketch the subject.

2. Try another sketch, taking twice as long.

6-8 Coneflowers.

6-9 Dogwood blossoms on a branch.

6-10 A sugar maple, Northampton, Massachusetts; broad-stroke pencil.

RELATIONSHIPS

In leisurely sketching, you usually have time to take some care in estimating sizes and shapes and thinking about composition. A viewfinder (see Chapter 2) may be useful both to help select the portion of a subject to include in the sketch and to aid in planning the composition, as it was for the sugar maple that I sketched in Northampton, Massachusetts (6-10). As you practice sketching, you will quickly see the

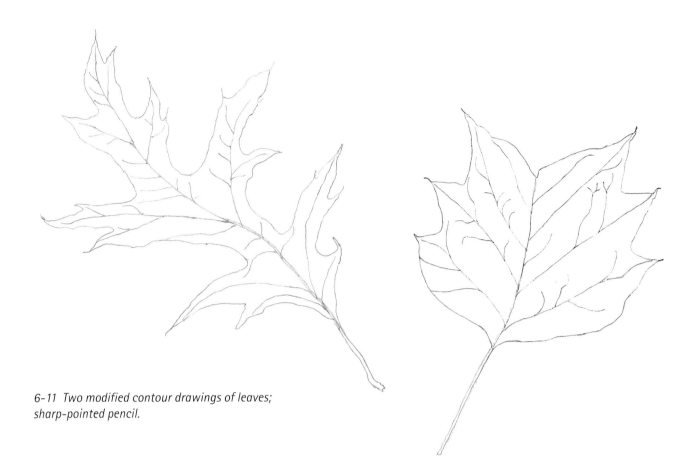

6-11 Two modified contour drawings of leaves; sharp-pointed pencil.

importance of relying on relationships among the parts of a subject to achieve realism. Considering a tree again, ask yourself how the heights of the branches above the ground compare on the left and right sides of the tree. For a person sitting in a chair at a table, how do the lengths of the various parts of what you see compare to each other: the height of the table from the ground, the length of the arms of the chair, the dimensions of the person's shoulders, and the top of his or her head?

A simple example of using relationships to achieve realism can be seen in drawing a leaf (6-11). Here are some questions to consider as you work:

◆ Does the central vein roughly divide the leaf in half?

◆ Is each half a mirror image of the other half?

◆ Are all the "teeth" (serrations) around the leaf about the same size?

◆ How do the veins compare with each other: which is the longest, the shortest, the most prominent?

◆ Do the secondary veins attach to opposite positions along the central vein?

As you note relationships, a few preliminary dots can indicate placement for parts of the sketch as a guide. For example, for a flower's bloom and leaves, dots could show locations on the paper of the bases and tops of a few leaves and of the sides, top, and bottom of a bloom among the leaves. Shading or lines in the finished sketch will cover the dots.

CONTRAST

In selecting the subject and planning the sketch, the artist uses contrasts of clarity, pattern, and emphasis to aid the composition. For example, in drawing a flower surrounded by leaves, placement of the flower and contrasting details,

as well as shading, allow the flower to become the center of interest, as in the sketch of a geranium in 6-12. The photograph of daffodils (6-13) is a ready-made subject with good contrast. Try using it for a few sketches.

The importance of showing contrast is especially obvious in sketching or drawing trees; without contrast, Photo 6-15 and Figure 6-14 would look flat.

Regardless of what you try to show in a sketch or drawing, try to base it on what you see, not on what you think you see, even though the subject may need emphasis on some parts or special placement of some parts to aid the composition. This means using your knowledge of perspective and foreshortening. Deviations from what you see should be deliberate.

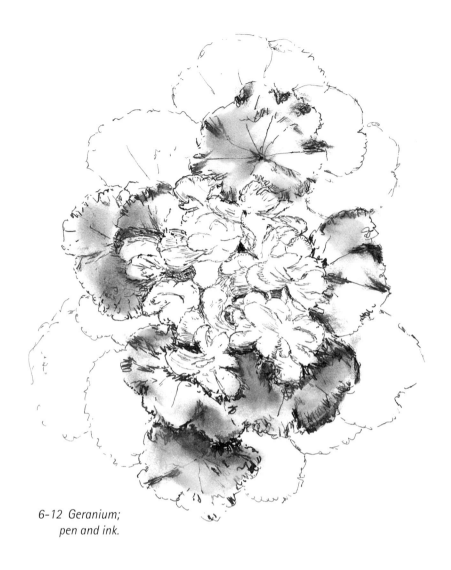

6-12 Geranium;
pen and ink.

6-13 Daffodils, a photo with good contrast.

SIMPLIFYING

"Simplify, simplify, simplify" is an old rule that not only saves time, effort, and patience, but generally helps by compressing the message in the work. The goal in sketching is to record an impression you had on seeing a subject or an experience you had; you do this for yourself, or perhaps for others. The goal is seldom to produce a museum-quality drawing. Sketching can be satisfying if you avoid the stress of trying to achieve perfection.

6-14 Contrast is important in this sketch, done in broad-stroke pencil.

6-15 Contrast is important in understanding the shape of a tree.

A SIMPLE SKETCH, STEP BY STEP

Holly Branch

Figure 6-16 shows steps involved in drawing a holly branch with a soft pencil:

1. A few dots with a 2H pencil on the paper laid out the approximate dimensions (measured by the thumb-on-pencil technique described in Chapter 2), from the bottom of the stem to the tip of the highest leaf.

2. I made a modified contour drawing to outline the leaves and stem.

3. Shading with 3B and 5B pencils using the broad-stroke method was done in the directions of the secondary veins of the leaves. I started drawing with the deepest shade to aid my planning of the range of shading.

4. In the finished sketch, the shading has covered the outlines made earlier.

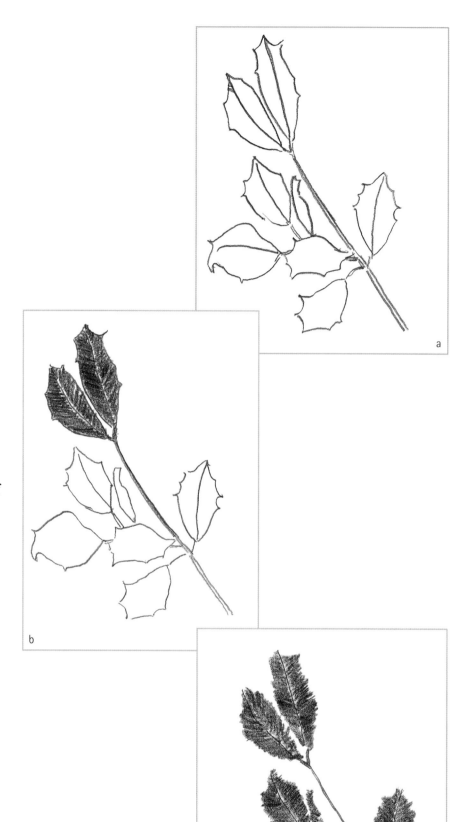

6-16 A simple step-by-step drawing. a. A contour drawing of the holly. b. Shading begins with the deepest shade. c. The finished branch; outlines have been covered by shading in many places.

Tree Trunk

Figure 6-17 shows steps in the sketching of the lower trunk of a white oak tree:

1. With a few dots, I laid out the major dimensions of the tree trunk—the height and width of the trunk and the width of the roots.

2. Then I made a modified contour drawing to outline the tree trunk and roots.

3. Using the broad-stroke method, I began drawing with the deepest shade to aid my planning of the range of shading.

4. I drew several deeply shaded parts of the trunk to suggest shadows on the rough bark.

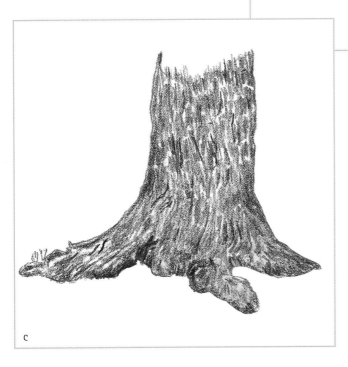

6-17 A step-by-step drawing of a tree trunk. a. A contour drawing of the trunk. b. Shading begins with the darkest darks to aid in planning the range of shading. c. The finished tree trunk; deeply shaded parts suggest shadows.

CHAPTER 7

Executing Moderately Detailed Drawings

An artist may find great satisfaction in seeing a subject clearly enough to produce an accurate picture on paper, one that conveys a sense of order, beauty, and artistry. I think of a drawing as requiring more care than a sketch. A drawing is a project that may take from an hour or two to many hours for completion. The process of drawing includes much more detail than sketching does.

7-1 Opening in the Brandywine River bank might be an interesting basis for a drawing.

ON-LOCATION DRAWING

Sometimes a subject is impressive or memorable, almost ideal, and is suitable for drawing in a few hours (7-1). The tree trunk I drew in 7-2 is an example. Making such a drawing may require only small adjustments of the subject as you see it. Environmental conditions may permit you to spend enough time on location to complete the drawing there. (The right conditions are a day that is not too hot or cold or windy and a safe, suitable place to sit for two hours or longer.) Chapter 8 provides a step-by-step example of an on-location drawing.

On-location drawing benefits from the use of a viewfinder, as described in Chapter 2, to help select the area of the view to be included and to measure dimensions. Estimating lengths, distances, and angles with a pencil or pen may be necessary as drawing proceeds (see Chapter 2 for details). You can make some light dots or lines, to be covered by the finished drawing, to mark critical locations on the paper.

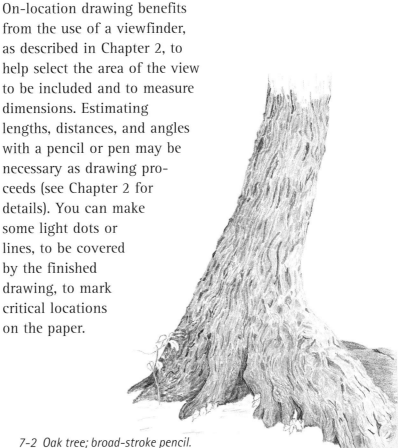

7-2 Oak tree; broad-stroke pencil.

7-3 Hayek home, St. Paul, Minnesota; pen and ink and some broad-stroke pencil.

HOME OR STUDIO DRAWING

Time may be too short to make an on-location drawing. The subject may be so complex that several hours would be needed to complete it. Either case requires you to draw at home or in a studio, relying on sketches, photographs, and your memory. Pencil or pen-and-ink drawings that require 20 to 30 hours to finish obviously must be done where it is convenient and comfortable to work. For such drawing, famil-iarity with the subject is a great help.

Chapter 9 provides a step-by-step memoir of how I executed a detailed drawing at home in my studio. Such a drawing usually requires careful laying out, planning that involves making preliminary sketches and measurements.

The drawing of my boyhood home in St. Paul, Minnesota (7-3) and the drawings that follow in this chapter all required the kind of detailed and careful planning described in Chapter 9.

USE OF PHOTOGRAPHS

Photographs are memory aids. They provide the information you may need for parts of a picture. But a drawing made with the aid of a photograph must be more than a copy of the photograph if it's to convey a sense of the experience of seeing the subject. Using photographs as aids in drawing allows you to see important details as well as parts of the actual subject that need adjustment to make a good composition.

For subjects that are complicated, such as the abbey shown in 7-4 or quick-moving animals (7-6), or growing things like flowers that open and close and move during the day (7-5) and may require a long time to draw, photographs are helpful tools. There is more information about photos in Chapter 2.

7-4 Bolton Abbey.

7-5 Water lily; many flowers turn or open and close during the day. A photo is a useful aid in such a case.

7-6 This fast-moving Canada goose won't stand still for a sketch, so a photo is useful to have.

Photographs are useful, but a more essential element is seeing the actual subject matter clearly. You can then have the image in mind and, with the help of sketches and photographs, you can create a detailed drawing of the subject.

CHOICE OF MEDIUM

The choice of pen and ink or pencil as the medium depends first on your preference and then on the limitations imposed by the subject. For example, pen and ink seemed best for the siding and vertical shingles in the drawing of my home (7-3), but broad-stroke pencil provided shading beneath the first-floor windows. In drawing the High Bridge in St. Paul, Minnesota (7-8), I found that broad-stroke pencils were best for rendering the pavement, girders, and background and sharp-pointed pencils were best for the railing and other narrow details.

Whether the subject is a scene from nature or something manmade such as a building, the choice of medium and the way of rendering the drawing (lines or dots with a pen or pencil or shading with broad-stroke pencils or charcoal) can produce impressions of texture.

The drawings shown in the gallery section illustrate ways to show several textures. The drawing of a piece of bark shown in the gallery (page 122) is an example of how the

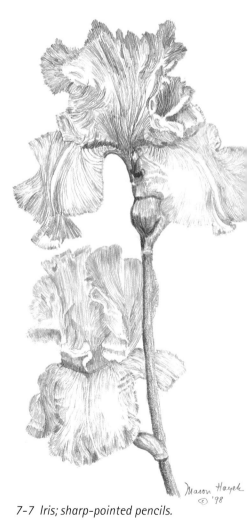

7-7 Iris; sharp-pointed pencils.

results depend on the medium. The drawing was simple enough to require only minor planning. The use of broad-stroke pencils gave the impression of a variety of textures in the bark. The two drawings of the Lafayette headquarters in the gallery section give you an idea of how two different media portray the same subject.

Sharp-pointed pencils were ideal for the drawing of the iris (7-7). The directions, lengths, and depths of shade of the lines that I drew showed the shapes and textures of the iris petals. The techniques used for the iris are applicable to a variety of drawings, from scenes in nature to portraits.

PLANNING THE COMPOSITION

Building a detailed drawing after you select the medium involves planning the composition and then laying out the drawing with sufficient care to achieve the desired accuracy. Composing the picture may be simple for a subject without surrounding parts, such as a portrait. But for many subjects, it is critical to use the principles of composition given in Chapter 3.

A subject embedded in surrounding features, such as a house with shrubbery and trees, requires careful placement to help emphasize

7-8 High Bridge, St. Paul
Minnesota; broad-stroke and sharp-pointed pencils.

the main parts and perhaps frame the house, as I did when I drew the David Wilson House in Odessa, Delaware (7-9).

The drawing of the little stern-wheeler on the Kentucky River (7-10) uses the high railroad bridge and the hills that line the river to complete the composition.

The composition of a scene as you find it in nature may be attractive and may need no change; if not, you can move parts of the scene to place the main feature at the center of interest. As an example, the

dead tree in the view of the White Mountains (3-8) is positioned left of center, as it actually was in the view I saw, where the tree was balanced by the distant mountains. In the drawing of the cove in Chapter 8, however, I replaced a pine in the foreground of the scene with a birch to improve the composition.

The effort and time needed to lay out a drawing depend on the subject. A scene in nature may require only a few judiciously placed dots or lines to mark its essential features, or a

7-9 David Wilson House, Odessa, Delaware; pen and ink. Such a drawing requires careful planning.

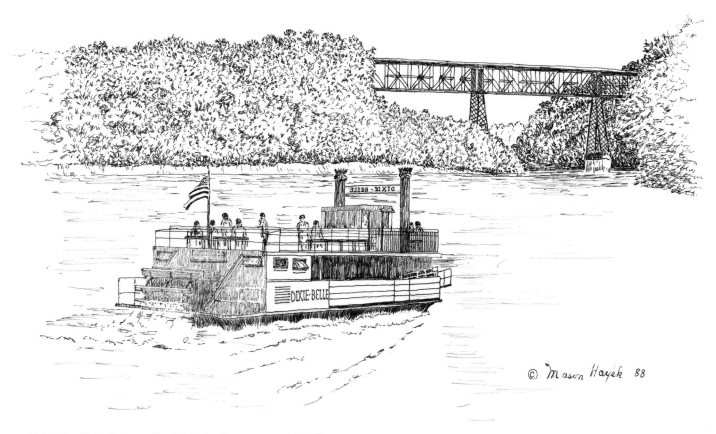

7-10 *The Dixie Belle on the Kentucky River; pen and ink. The bridge and hills complete the composition.*

modified contour drawing of its parts may serve your needs. For a building, it's usually necessary to be especially careful in laying out edges, such as the ends or sides of the building, roof, windows, doors, and chimneys. This part of the planning may require the use of a T-square, triangle, and ruler, tools that seldom would be used for the final rendering. Attention to relationships among the parts is essential. The work done in laying out the drawing may become tedious, but the reward comes when you start on the final drawing with pencils or pen and eventually complete a drawing that has the desired (perhaps impressive) accuracy and carries your feeling for the subject. When the process of drawing is complete, what you have seen has become an arrangement of lines, dots, or shading on paper, a metaphor for the essence of the subject.

The artist can arrange the lighting to suit the needs of the drawing. Before you begin a complicated drawing, it is a good idea to study the scene at various times of day, taking reference photos and making sketches, to see what lighting looks best.

Careful consideration of depths of shade is essential for emphasis and clarity. In the drawing of a Kentucky stone fence, the depth of shading of the stones depends on the shapes of the stones and on the light coming from the left. The blacks of the stones contrast with the shades of the background trees, which are less intense, so the stones are the center of interest (7-11).

Making a Moderately Detailed Pencil Drawing

Goal: To make a pencil drawing of a scene in nature or of another subject of similar detail

Subject: One of the photos from 7-12 to 7-20, a similar photograph, or a subject to draw on location

Materials: Broad-stroke and/or sharp-pointed pencils, auxiliary tools, viewfinder, a sketchbook at least 10 × 12 in. (25.5 × 30.5 cm) or drawing paper of similar size.

Directions:

1. Consider the details of the subject or photograph, asking yourself the following questions. Use the viewfinder to help you:

 ◆ Should the drawing be wider than it is tall, or the opposite?

 ◆ Is the composition pleasing regarding its center of interest, direction of light, unity, and pattern?

 ◆ What medium will be best for the drawing?

 ◆ To make the scene look realistic, what contrasts are important?

 ◆ How much of the subject should I include?

2. Using an appropriate method of measurement (see Chapter 2), lay out the locations of important features of the subject by placing a few dots on the paper.

3. Make a modified contour drawing, and adjust the parts whose locations are different from the locations of dots.

4. Proceed with drawing in your preferred medium, starting with the deepest shade first.

5. Complete the drawing by making any final adjustments that are needed.

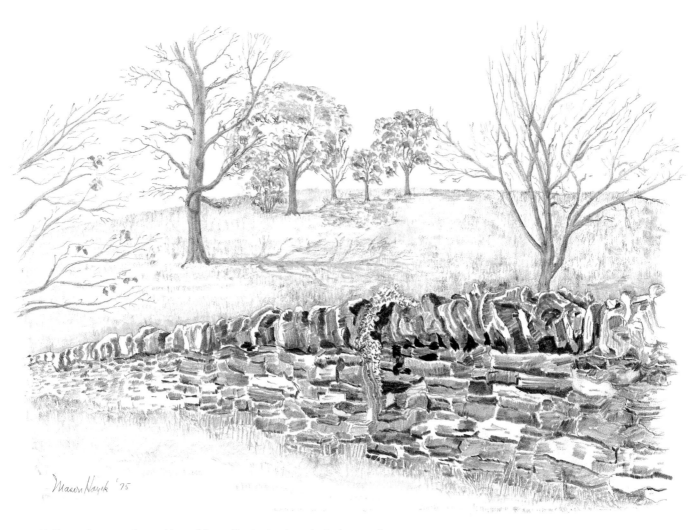

7-11 Kentucky stone fence, Harrodsburg, Kentucky; broad-stroke pencil.

MISTAKES, CORRECTIONS, AND ADDITIONS

Solving the variety of problems that come up in drawing is usually easy and satisfying, but occasionally more difficult problems arise. One is the need to correct a mistake. The tools to use are described in Chapter 2. Correcting pencil or charcoal lines or shading requires only careful erasure while using an erasing shield to avoid damaging the paper. Removing or correcting errors in ink requires special care. A single-edge razor blade or a knife may remove most lines, and careful erasure with the use of an erasing shield may help take off any remaining ink. If the area is small, the correction may be invisible.

At times you may consider making an addition to the picture. For example, a scene in nature might be improved by adding a tree. If you're not sure it's what you want to do, making an addition directly to the picture could be an irreparable mistake. Here tracing paper is helpful. Draw the feature that you are thinking of adding on the tracing paper, cut out that drawing, and place it over the main drawing. Review the drawing to see if it will benefit from the addition. If you are happy with the results, add the traced feature to your drawing. If not, try other solutions until you find one that works well.

7-12 Pond in Winterthur, Delaware.

7-13 Two trees by the Brandywine River.

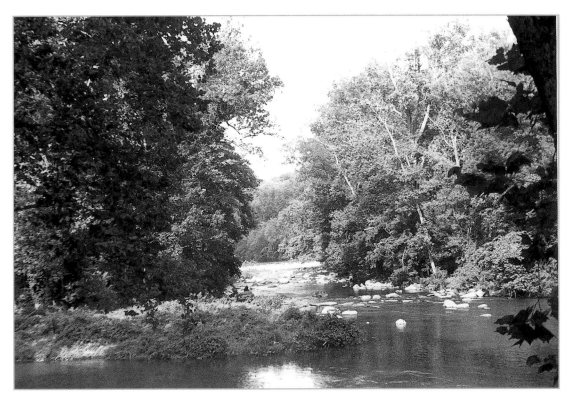

7-14 Opening in the Brandywine River bank.

Making a Moderately Detailed Pen-and-Ink Drawing

Goal: To make a pen-and-ink drawing of a scene in nature or of another subject of similar detail

Subject: One of the photos from 7-12 to 7-20, a similar photograph, or a subject to draw on location

Materials: A pen of your choice, auxiliary tools, a viewfinder, and a sketchbook at least 10 × 12 in. (25.5 × 30.5 cm) or drawing paper of similar size.

Directions:

1. Follow the directions of Exercise 17, but substitute pen and ink for pencils.

2. When the drawing is complete, consider which medium would be preferable for similar subjects, pencil or pen and ink.

7-16 Rose and buds.

7-15 Plants in summer.

7-17 Black oak.

Making a Moderately Detailed Charcoal Drawing

Goal: To make a charcoal drawing of a scene in nature or of another subject of similar detail

Subject: One of the photos from 7-12 to 7-20, a similar photograph, or a subject to draw on location

Materials: Charcoal sticks or pencils, auxiliary tools, a viewfinder, and a sketchbook at least 10 × 12 in. (25.5 × 30.5 cm) or charcoal paper of similar size.

Directions:

1. Follow the directions of Exercise 17, using charcoal instead of pencil.

2. When the drawing is complete, compare the benefits of drawing with charcoal, pencils, and pen and ink.

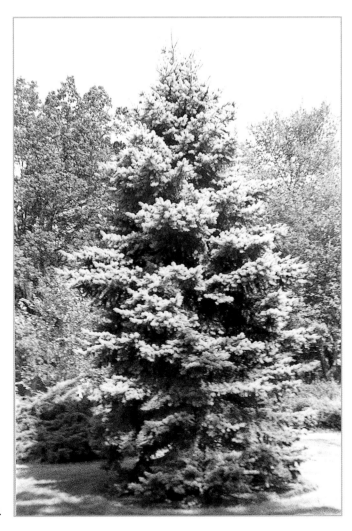

7-18 Spruce tree.

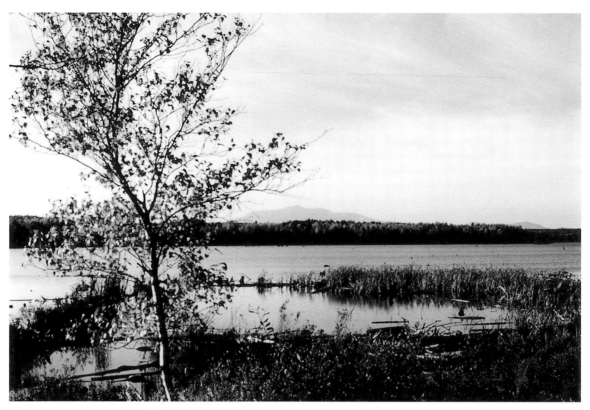

7-19 View to Mt. Katahdin, Maine.

7-20 Dogwood.

CHAPTER 8

Detailed Pencil Drawings

A detailed pencil drawing may be done with the broad-stroke technique or with pointed pencils. Either method can produce pleasing results. The choice between the two depends on the artist's opinion as to which method may be better for a particular subject and on his or her satisfaction with previous drawings using one or the other method.

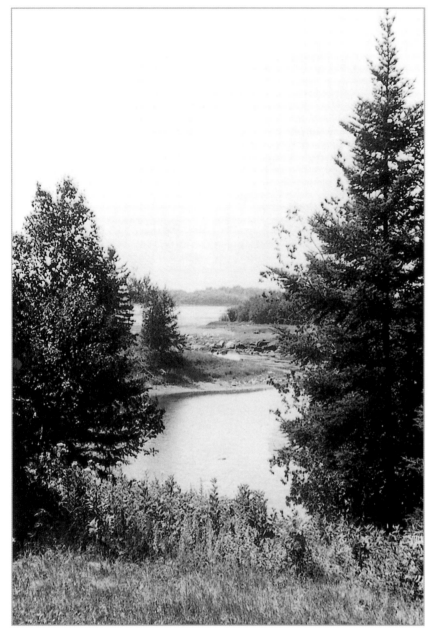

8-1 *Photograph of cove near Penobscot Bay, Maine. Only part of the scene I drew is included in this photo, as the view I chose was wider.*

A FIELD DRAWING OF A COVE

When I first found the beautiful cove shown in 8-1, near West Brooksville, Maine, and Penobscot Bay, I was armed with drawing materials but no camera. Taking the photograph came the day after I'd drawn the picture. Here are the steps I took as I drew directly from the scene. I chose to "adjust reality" by showing the near-left and near-right sides of water inlet (not shown on the photo).

1. My equipment consisted of 2H, B, 2B, and 4B pencils, a sketchbook of dimensions 11 × 8½ in. (about 28 × 21.5 cm), a piece of sandpaper for sharpening the pencils, a viewfinder, and a kneaded-rubber eraser. The 2H pencil was sharpened to a point, and the other pencils were sharpened to a chisel point for broad-stroke drawing (see Chapter 2 for details).

2. Using the viewfinder, I easily selected the part of the scene to include in the drawing: the shapely water inlet, the distant bay, and trees to frame the picture. (I included the left and right edges of the water inlet, which are not shown in Photo 8-1.)

3. Using a pencil to estimate the dimensions of the scene (see Chapter 2), I found the necessary ratio of dimensions of the chosen part of the scene to the dimensions of the drawing paper in the sketchbook. The critical sizes in the scene were the height from the foreground grassy area to the tops of the nearby trees and the width from the tree on the left to the top of the woods above the right side of the water inlet. The critical dimensions for the drawing were the height and width of the paper on which the drawing had to fit. Three pencil lengths would span the width of the scene (with the pencil held at arm's length), which would have to fit onto paper 1½ pencil lengths wide (measuring with the pencil held against the paper). Thus all pencil length measurements on the drawing

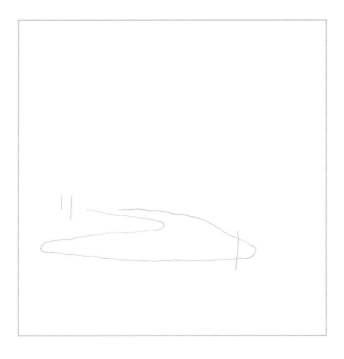

8-2 Modified contour sketch to start to lay out the Penobscot Bay scene with correct dimensions, concentrating on the foreground first. Sketch covers a wider area than the photo.

8-3 With the aid of a few measurements, I indicated where the distant shore and woods should be.

would be one-half the size of the pencil lengths measured on the scene.

4. With the 2H pencil, I drew the water inlet by the modified contour method, drawing on the paper as I watched the scene and imagined the pencil following the shoreline (8-2). I glanced repeatedly at the paper to see what I was drawing and to ensure that my picture of the shoreline approximately matched what I saw. After completing the outline of the water, I checked for correctness by using the pencil-length method to discover where I should make small adjustments with the eraser and pencil for accuracy. Short vertical guide lines

showed where to place the foreground trees. As with any drawing, the foreground had to be placed and drawn first to ensure that the background would be behind the foreground.

5. With the aid of pencil measurements, I placed a few guide lines to show where the distant shore and the woods would be (8-3).

6. The sun was behind the trees on the left, convenient for some shadows on the ground and for shadows among the tree branches to aid three-dimensional effects.

7. Using the chisel-shaped pencils, I drew in the inlet's shoreline, the beach and

woods to the right of the inlet, the three trees on the left, and the distant shore. The selection of the pencils and the pressure applied determined the depth of shade. Turning the chisel-shaped pencil 90° and using its narrow side allowed me to draw lines instead of broad marks for some parts of the drawing (8-4).

8. The drawing proceeded. After starting the pine tree shown on the right in photograph 8-1, I became aware that the tree would be too dense and dark, overpowering the rest of the drawing. The solution was to "adjust reality" by erasing the parts of the tree already drawn and replacing the pine with a birch.

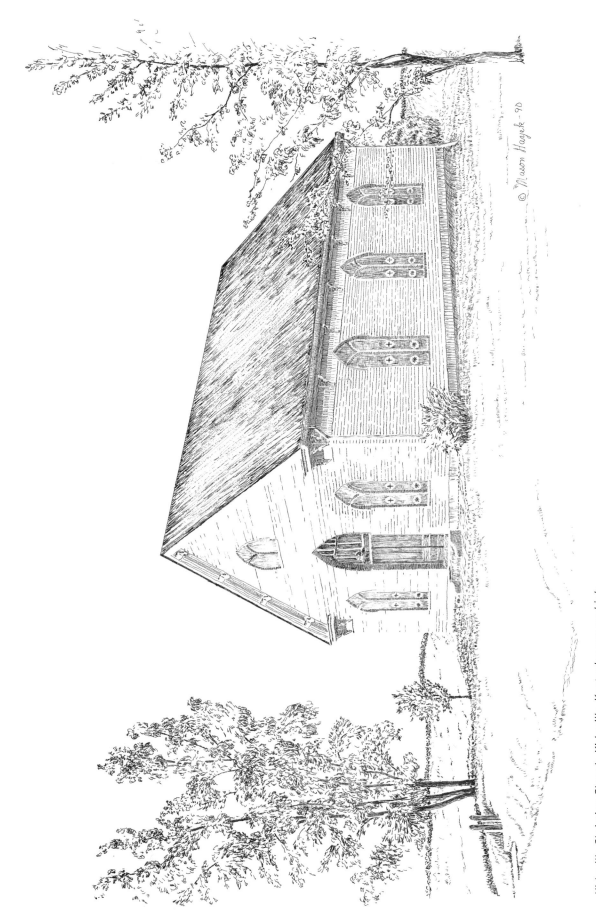

Kirksville Christian Church, Kirksville, Kentucky; pen and ink.

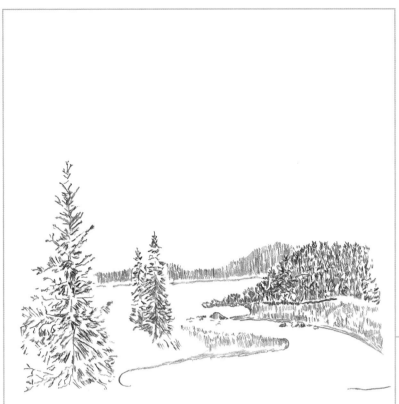

8-4 Broad-stroke pencils have been used to add details. The tree on the right has not been added yet.

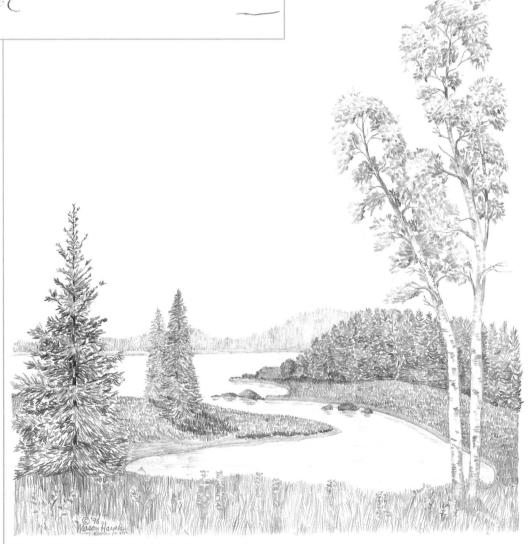

8-5 Cove of Penobscot Bay, West Brooksville, Maine (final drawing).

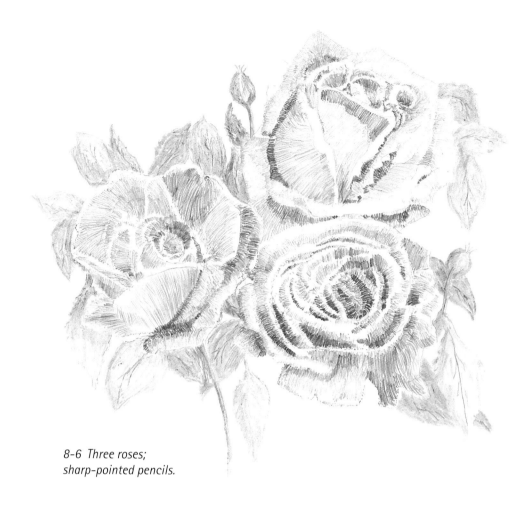

*8-6 Three roses;
sharp-pointed pencils.*

The birch trunk and branches would be light-colored above and white below against dark woods, and the foliage would be open and feathery. I chose shapes for the birch to contrast with other shapes in the drawing and to balance the trees on the left (8-5).

9. The last step consisted of drawing the woods to the right, the boulders along the edge of the water inlet, the distant shoreline and woods, the grassy land to the left, and the shore with a few flowers in the foreground. The nearest woods, like the trees, required the 2B and 4B pencils, and the distant woods required the B pencil, used lightly to suggest

distance. A few light horizontal lines suggested ripples on the water. The final drawing is shown in Figure 8-5.

The procedure described above is similar to the way I make other broad-stroke drawings on location.

A SHARP-POINTED PENCIL DRAWING OF ROSES

The drawing of the roses (8-6) illustrates how I draw flowers with HB (or F) pencils that have been sharpened to points. The directions, lengths, and depths of shade of lines show

the shapes and textures of the flowers. The technique is the same for drawing a wide variety of subjects.

For this drawing of roses, the first step was to outline the flowers by the modified contour method, paying attention to placement of the flowers on the paper for a good composition. Then I drew the picture line by line, curving the lines to show the shapes of the petals as they stood or drooped. Light pressure on the pencil produced light shades, especially when the lines were not close together. Lines drawn with greater pressure and spaced close together produced deep shades.

CHAPTER 9

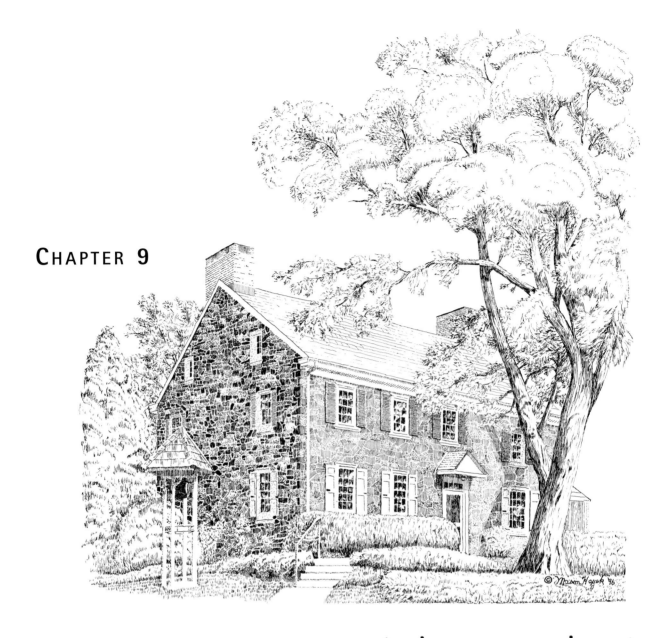

A Detailed Pen-and-Ink Drawing of a House

Pen and ink can produce pleasing results, whether for detailed, slow drawing or for rapid sketching. A slow drawing can show excellent detail. A sketch can be a quickly executed record of a brief encounter with a subject such as a person, a flower, or a landscape. A detailed pencil or pen-and-ink drawing may require 30 to 40 hours of work.

Usually this is far more time than an artist can spend at a scene. To make such a drawing you need either a phenomenal memory and sketches, or photographs and sketches of parts of the subject. Some changes from what you see may be necessary to make an attractive composition and to emphasize some parts.

Photographs provide you with details of and facts about the subject for reference during the drawing process. Ideally, you will produce a drawing that offers more than photographs alone can provide.

The 200-year-old building known as the Jones House was a pleasing and challenging subject for a detailed drawing. I chose to use pen and ink as the best medium to show detail. The building was the farmhouse on the property now occupied by Wilmington (Delaware) Friends School. In this chapter, I describe the steps I took to make the drawing.

1. Early in the project, I took five photographs of the house. They were taken from different positions and at different times. I chose the view shown in 9-1 as my preferred one. Figures 9-3 through 9-6 show the remaining four photographs of the house.

2. Before starting to make the detailed drawing, I made several quick sketches to help me become familiar with the house and its immediate surroundings and to learn some details that were not sufficiently clear in the photographs (see 9-2). The sketches were of the left chimney, the roof, the entrance overhang, the steps, the miniature bell house (lower left), and the large tree.

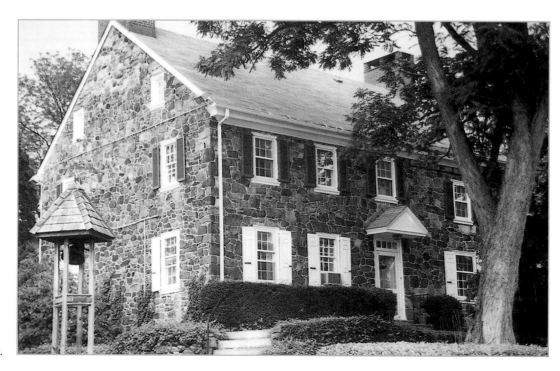

9-1 The view of the Jones House (Wilmington, Delaware) that I chose for my detailed drawing.

3. The large tree became an important part of the drawing. It is an anchor for the house and a means to help frame the house for an attractive composition. The trees at the left of the house completed the frame.

4. My equipment, besides the camera, consisted of Bristol board, smooth drawing paper, and a Rotring Rapidograph ISO technical pen with a 0.13 mm point. An 0.18 mm point would have let me show almost the same detail as the smaller point did.

5. For accuracy in sketching parts of the scene, I used the pencil-length measuring scheme for approximating some dimensions (see Chapter 2). I counted the number of rows of bricks in the chimneys and the rows of shingles on part of the roof.

9-2 Quick sketches of the Jones House were a way of preserving important information that might not be clear in a photo.

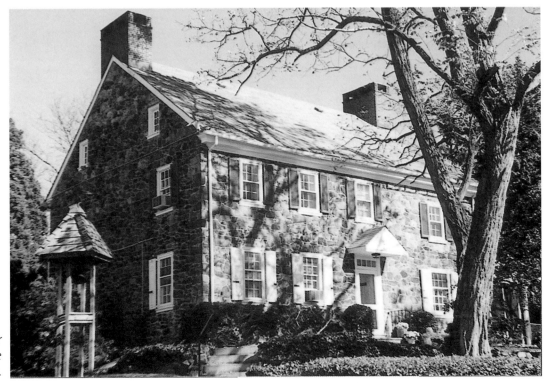

9-3 Another view of the Jones House.

6. I chose the overall dimensions of the drawing to be approximately 11 × 12 in. (28 × 30.5 cm), and placed the house on my paper as shown in Photograph 9-1.

7. Because the photographs contained only minor distortions, I could make dimensions in the drawing proportional to the dimensions in the photograph. The differences between the drawing and the photograph would then be in selection and emphasis of details, in the clarity of the various parts of the subject, and in the arrangement of the light. All the vertical features, such as the ends of the building, the edges of the chimneys, and the vertical edges of windows, shutters, and door became vertical in the drawing, even though the photograph might

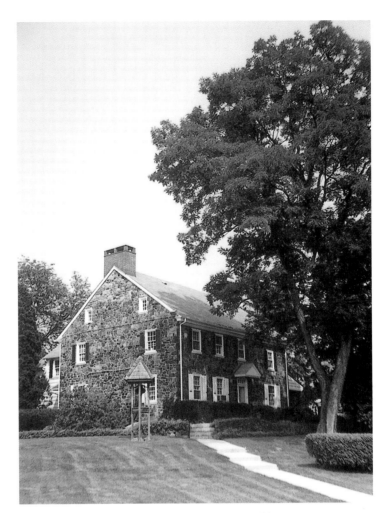

9-4 In this view I was much further from the subject.

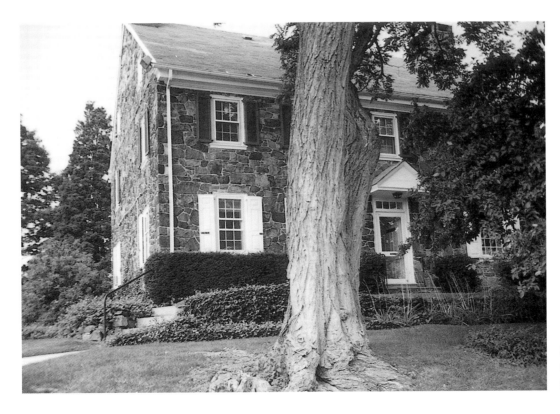

9-5 Another view of the Jones House.

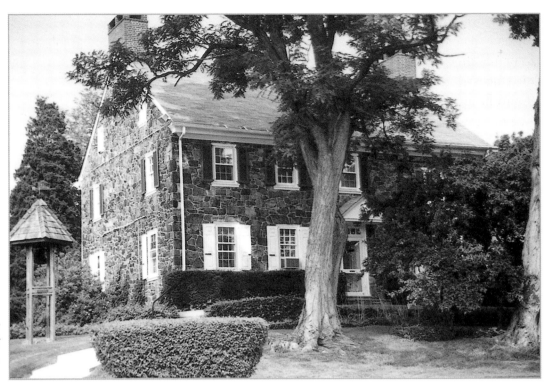

9-6 A little farther back than 9-1 or 9-3.

have shown these parts as slightly off vertical.

8. Representations of horizontal lines on the house had to meet the requirements of drawing in perspective. For example, the upper and lower edges of the roof were not drawn parallel to each other, but were drawn with consideration of two-vanishing point (angular) perspective. The lines on my drawing for the upper and lower edges of the roof came closer to each other as they got further away from me. Parts of windows at my eye level were horizontal, not tilted to match the roof lines.

9. Laying out such a drawing in pencil is a time-consuming, many-hour process that requires accuracy if the resulting drawing is to be realistic.

This stage of the work required measurement of many parts of the subject in the photograph. Then each dimension was multiplied by the ratio of the intended drawing dimension to the dimension seen in the photograph. For example, if the drawing is to be 1.6 times larger than the photograph, each dimension in the photograph (e.g., the length of the roof, the width of a window, the height of the chimney) must be multiplied by 1.6 for the drawing. The drawing took the shape shown in 9-7 as laying out proceeded.

10. It was necessary to lay out all critical features, including the spacing of rows of shingles (marked on the drawing with a series of dots for part of the way down from the peak of

the roof) but not to lay out details of windows or the shapes, sizes, and locations of the stones in the house. The latter features all could be improvised in the drawing process, based on details in sketches and photographs.

11. After careful laying out of the drawing was complete, inking could begin, first with the edges of the roof. These edges must be true, not wavy, and for that reason, drawing a few lines along the edge of a ruler or another straightedge was necessary. This was the only place I used such an aid.

12. The remainder of the drawing was done freehand. The depth of shading depended upon the closeness of the lines. The closer together the lines were, the deeper the shade.

13. Because I wanted the front of the house and the large tree to be prominent, I arranged the sunshine to be falling on the front and a shadow of the tree to fall on the house, as shown in the final drawing (9-8). This arrangement allowed sunshine also to fall on the shrubbery. I knew that the highlights would not detract from the house the way deeply shaded shrubbery would. In addition, sunshine on the roof let me show the lines of shingles only where the shadows of the tree fell.

14. The contrast of shading between the front and side of the house and the sunlit and shaded sides of the left chimney gave a three-dimensional effect. Sunlight and shadow on the tree gave it a rounded appearance. Sunlight on the tree's foliage let me simplify details to avoid detracting from the house.

15. The techniques of inking are evident in the final drawing. The order of inking was:

◆ First the large tree and shrubbery, to see which parts of the house would be hidden

◆ Then the edges of the roof, avoiding drawing lines over the tree

◆ Next the windows and shadows on the shutters to show the deepest shade of the drawing

◆ Then the shingles and the bricks of the chimneys, with the number of lines of shingles and the size and number of bricks in accord with the photograph and sketch

◆ The small bell house

◆ The stonework on the side and front of the house, with attention to the differences in shade to show the front in the sunshine, the side in the shade, and light mortar between the stones

◆ Finally came inking of the tree on the left of the house to help outline the left edge of the roof, and then inking of all the remaining details, including the porch to the right of the tree, the steps and step railing, the sidewalk, and the grass.

16. After the drawing was complete, the last step I took was to erase any penciled construction lines that remained and to sign the finished work.

The total time for making the drawing, including layout, was approximately 35 hours.

9-7 Layout of the Jones House drawing.

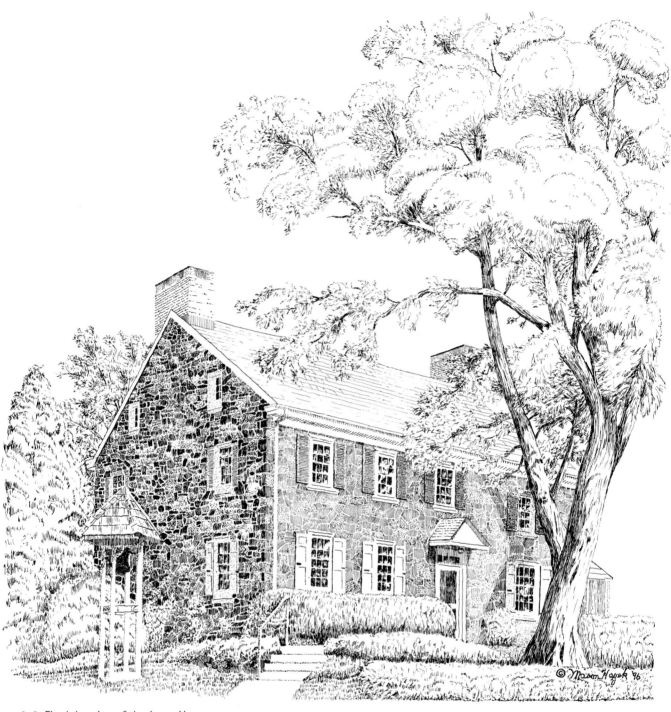

9-8 *Final drawing of the Jones House,*
Wilmington, Delaware; pen and ink.

Opposite: Melrose Abbey,
Melrose, Scotland;
broad-stroke pencil.

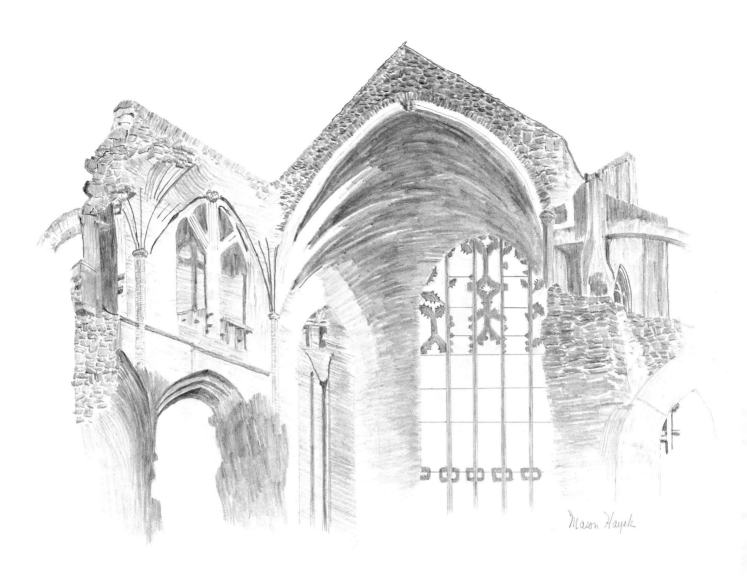

Gallery of Drawings

Here are some of my favorite drawings, done over the years. I've indicated the medium in which each was done. I hope these drawings are an inspiration to you as you travel along the path of your own growth in drawing.

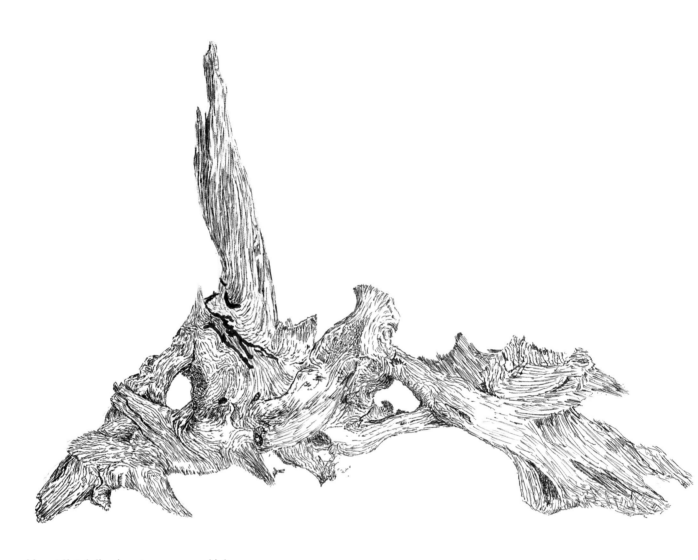

Mount Katahdin pine stump; pen and ink.

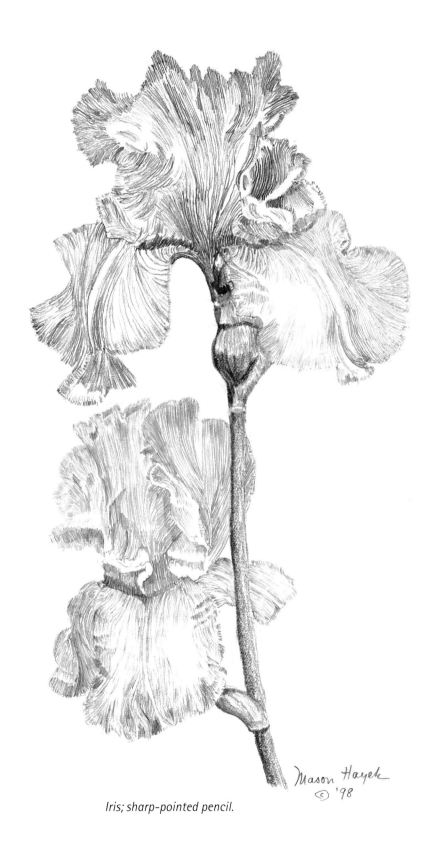

Iris; sharp-pointed pencil.

Mason Hayek
© '98

John Chadd House, Chad's Ford, Pennsylvania; pen and ink.

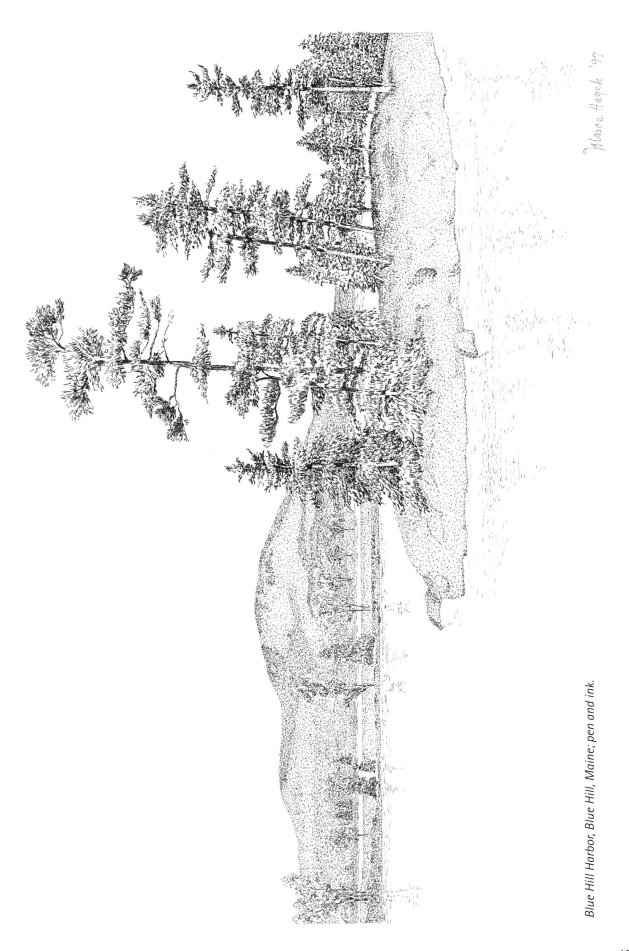

Blue Hill Harbor, Blue Hill, Maine; pen and ink.

January House, Odessa, Delaware; broad-stroke pencil. Broad-stroke pencil was ideal for showing the foreground tree and the shrubbery around the house. As usual, drawing the foreground preceded drawing the more remote parts. The foreground and background trees effectively frame the house.

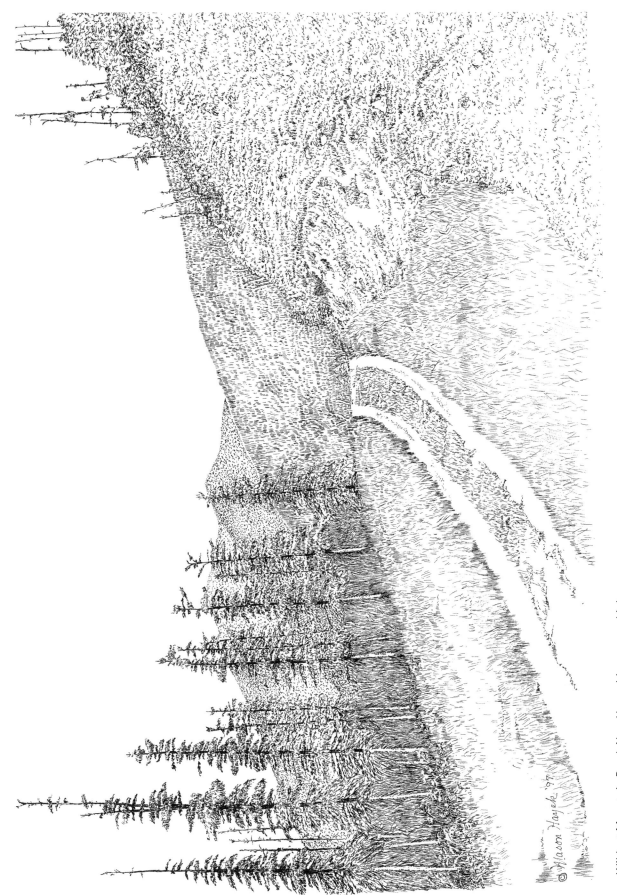

Wildcat Mountain Road, New Hampshire; pen and ink.

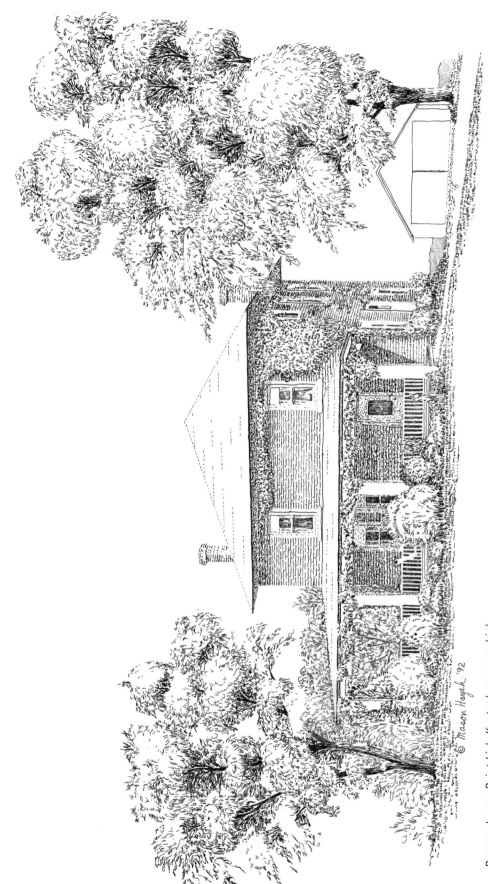

Burgess home, Paint Lick, Kentucky; pen and ink.

© Mason Hayek '92

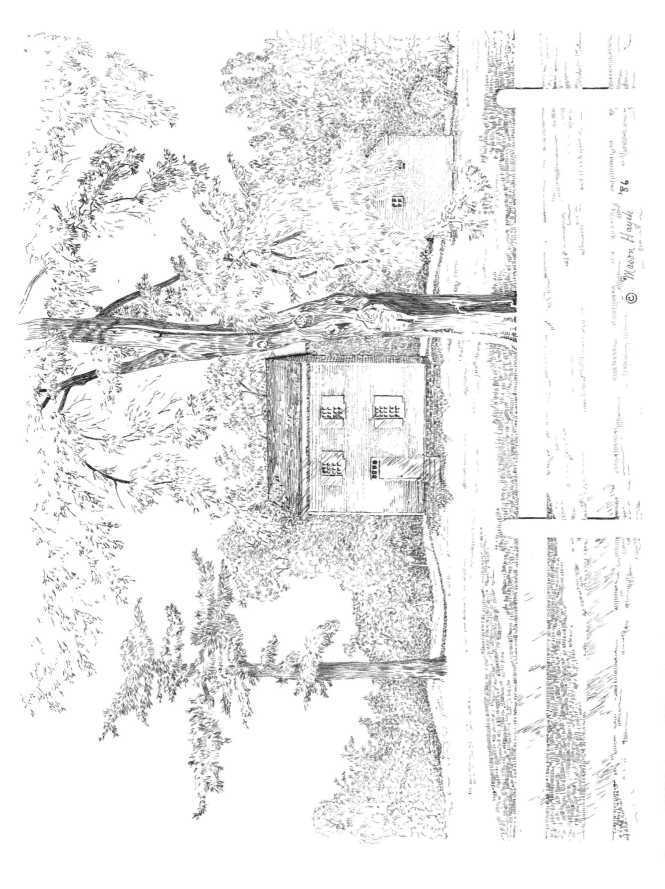

Pleasant Hill ("Shakertown") Water House, Pleasant Hill, Kentucky; broad-stroke pencil. The fence and the larger and remote trees frame the little house, the center of interest.

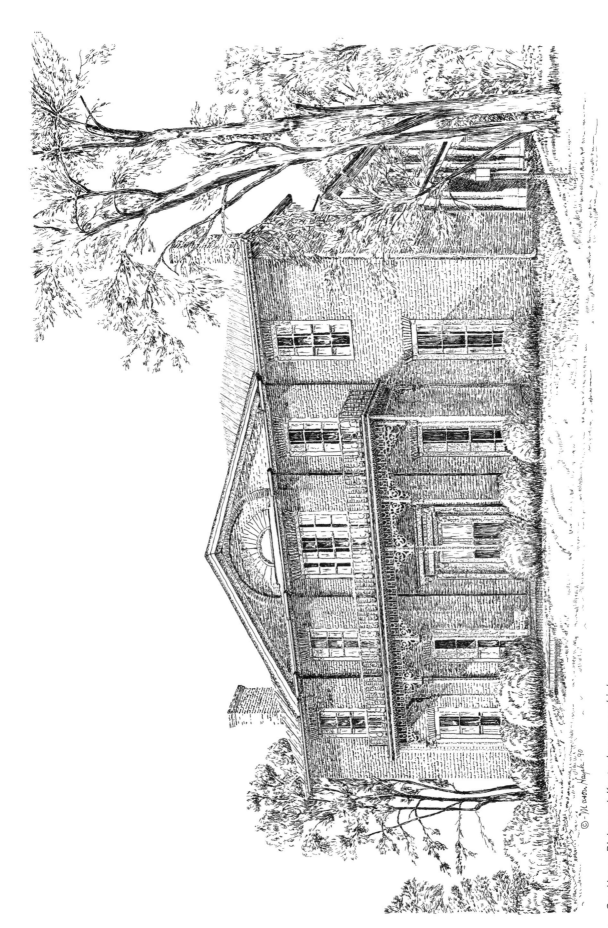

Coy Home, Richmond, Kentucky; pen and ink.

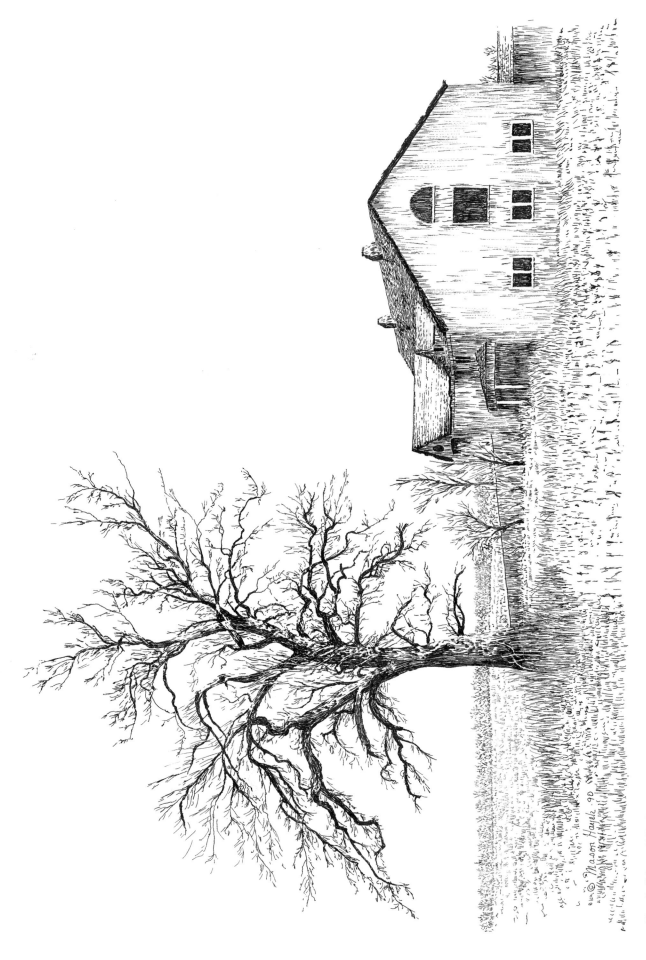

Blue Ball Barn, Wilmington, Delaware; pen and ink.

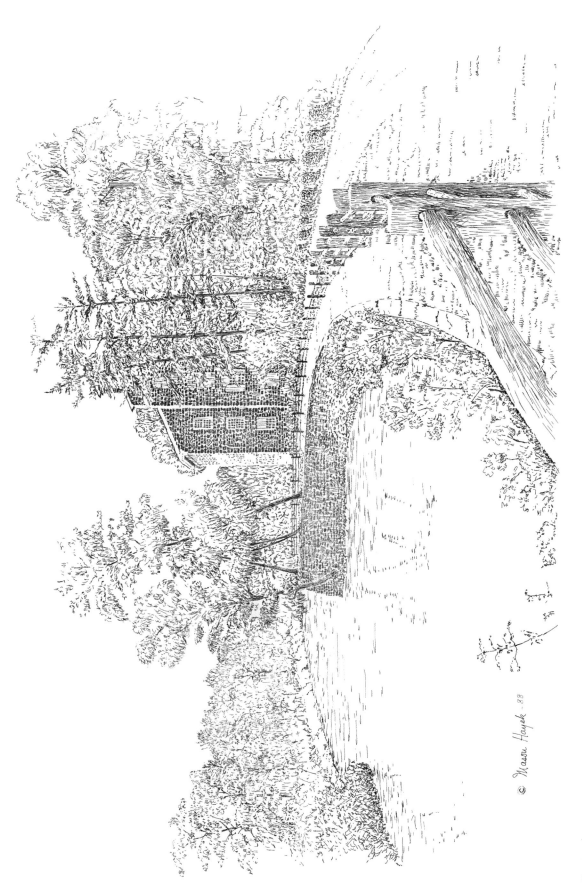

Hagley Museum, Wilmington, Delaware; pen and ink. The fence and river carry the eye to the center of interest.

© Mason Hayek - 88

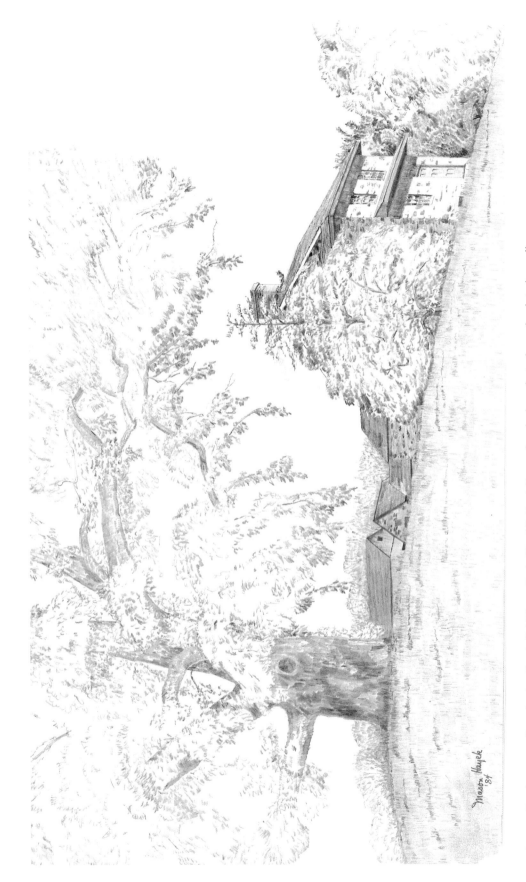

Lafayette Headquarters, Brandywine Battlefield State Park, Chadd's Ford, Pennsylvania; broad-stroke and pointed pencil.

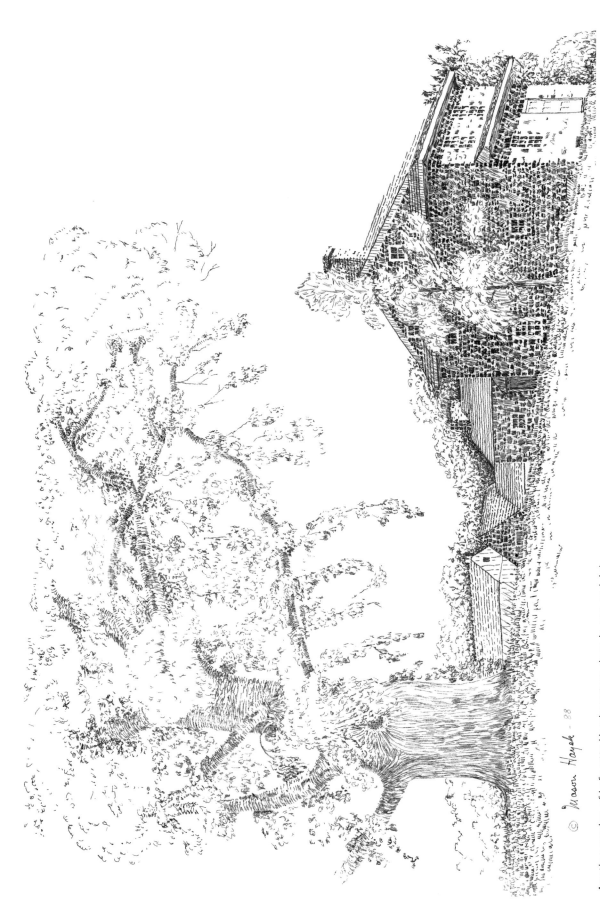

Another version of Lafayette Headquarters, done in pen and ink.

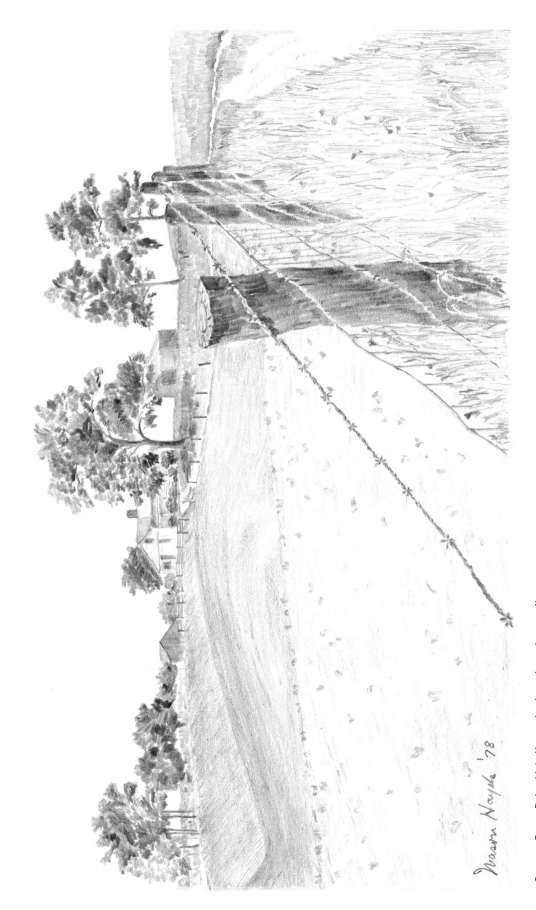

Cornett Farm, Paint Lick, Kentucky; broad-stroke pencil.

Brandywine State Park, Wilmington, Delaware; pen and ink.

© Mason Hayek - 90

White-oak bark; broad-stroke pencil.

Trees in the forest; broad-stroke pencil.

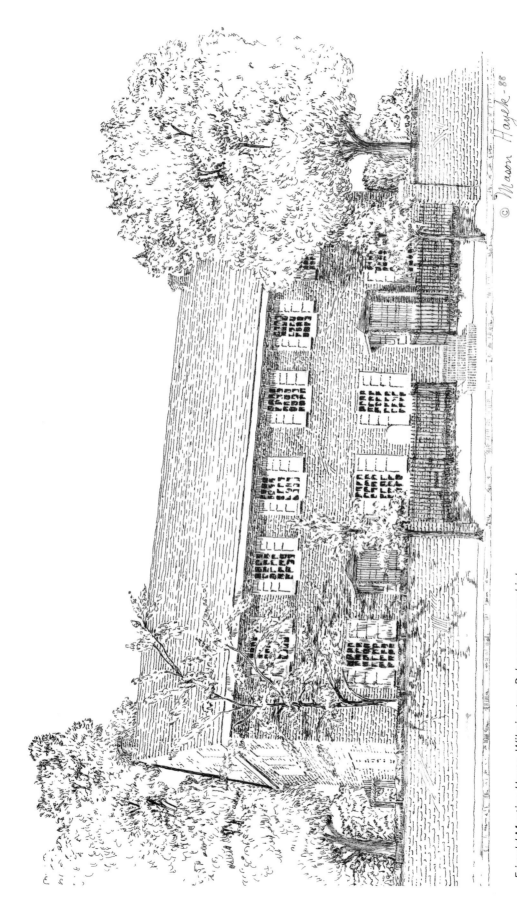

Friends' Meeting House, Wilmington, Delaware; pen and ink.

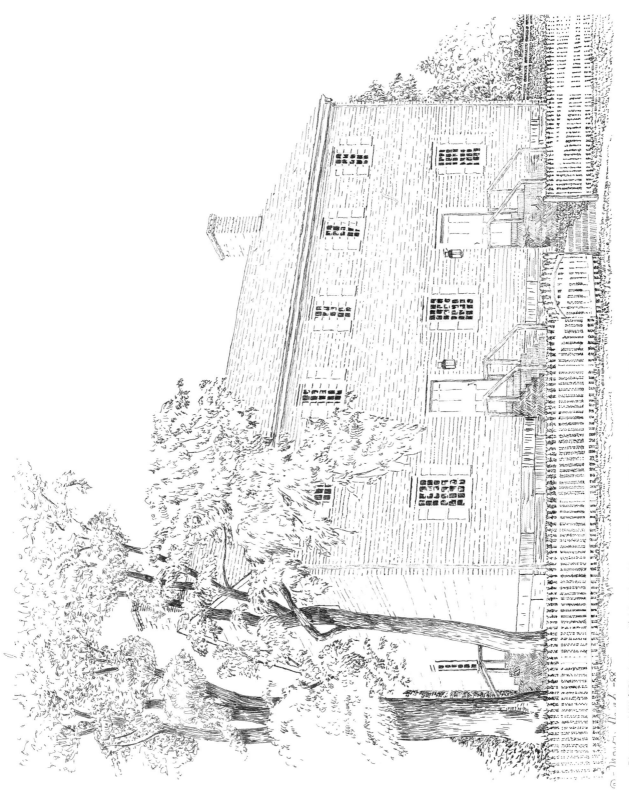

Pleasant Hill ("Shakertown") Meeting House, Pleasant Hill, Kentucky; pen and ink.

Water lily; Longwood Gardens; broad-stroke pencil.

Index